Ignite the Power of Art

Ignite the Power of Art

ADVANCING VISITOR
ENGAGEMENT IN MUSEUMS

Bonnie Pitman

Ellen Hirzy

Dallas Museum of Art
Yale University Press
New Haven and London

Inspired by the creative
spirit that all artists share,

this book is dedicated to the artists,

collectors, and donors who established

and nourish the collections of the Dallas

Museum of Art, the staff who care for,

present, and interpret the works of art that

galvanize our engagement with our public,

and, ultimately, the communities we serve

today and in the future.

CONTENTS

FOREWORD AND ACKNOWLEDGMENTS

Bonnie Pitman

The Eugene McDermott Director, Dallas Museum of Art

Ignite the Power of Art captures the vibrant and collaborative spirit in which we at the Dallas Museum of Art engage with our community. The publication records how this spirit came to be, describing a fundamental change in our approach to visitors and our understanding of our own mission, one that would allow us to connect art and people in the most thoughtful and purposeful way. We attribute this change to our adoption of a new means for understanding our visitors that we refer to as the Framework for Engaging with Art (FEA), the premises of which we now keep foremost in all our work. We are pleased to share with our readers the details of FEA's origins, purposes, and results that have been successful for the DMA.

As an art museum we have always focused on the collection, preservation, presentation, and interpretation of works of art. In early 2002 we made the commitment to our community to expand our attention to fully encompass our visitors, and embarked on an ambitious study of their preferences for experiencing art. Our purpose was not simply to increase attendance or provide more amenities, but to create valuable new opportunities for visitors to explore creativity in all its forms. To pursue this audience research systematically, we called on the expertise of the museum planning, evaluation, and research firm Randi Korn & Associates, Inc. (RK&A). From 2003 through 2010, RK&A, working closely with the DMA, conducted six studies with 3,394 individuals. These studies investigated our visitors' prior knowledge of art, their degree of emotional responsiveness to art and comfort in connecting with it, their behavior as art consumers, and their preferences for types of interpretation and programming.

The FEA findings have been shared with all levels of staff, and each and every member has been encouraged to experiment, collaborate, and continue the research. With the spirited support of staff, trustees, donors, and community partners, we have fully integrated what we have learned into the Museum's program. This creative collaborative process—not always an easy one—has required determination, dedication, and a willingness to experiment and to take risks.

Now, after eight years of inquiry and analysis, FEA guides staff collaboration in all areas: collections, exhibitions, interpretation, programming, marketing, and membership.

Through the research, and through each other, we have arrived at a way of working together internally and with our audiences to provide the maximum benefits to the institution and our community.

While this is a story about changes at the Dallas Museum of Art, it is also a story about our remarkable staff and our partners, Randi Korn & Associates. There are countless individuals who have contributed to the development of the Framework for Engaging with Art, and I would like to gratefully highlight a few.

John R. Lane, Director Emeritus and the former Eugene McDermott Director, was my staff partner on this undertaking for many years. Serving as his Deputy Director from 2000 to 2008 and succeeding him as Director in 2008 has been my greatest privilege. Jack was immensely supportive of the FEA research and experimentation in our exhibitions and programming, and his leadership and encouragement made a critical difference.

Gail Davitt, Chair of Learning Initiatives and The Dallas Museum of Art League Director of Education, is deeply committed to the evolving Framework and has provided a key leadership role in the complex work it has required of the entire staff. The DMA education staff has made enormous contributions over the years, implementing FEA values in creative, innovative programs. Special thanks go to Tracy Bays-Boothe, Carolyn Bess, Sharisse Butler, Susan Diachisin, María Teresa

García Pedroche, Elaine Higgins, Lisa Kays, Molly Kysar, Stacey Lizotte, and Nicole Stutzman, along with the rest of the Education Division.

Randi Korn has been a crucial partner in the development of the FEA studies. She and her colleagues at RK&A collaborated thoughtfully with the DMA to develop the six studies of onsite visitors, online users, and teachers. Her lucid insight into the research and its implications was essential to the success of our work. We could not have accomplished, or understood, so much without her guidance, and she has been a great advocate of our efforts.

Among the dedicated specialists who have generously contributed their ideas and imaginations, I would like to particularly recognize the curators currently working at the DMA for their deep commitment to collaborative work and the mission of engaging visitors more meaningfully with works of art: Anne Bromberg, Jeffrey Grove, Heather MacDonald, Olivier Meslay, Carol Robbins, Kevin Tucker, Roslyn Walker, and Charles Wylie. Their dedication and innovation have played a crucial role in the development of new exhibitions, collection projects, and programs to engage our visitors. Former Senior Curator Dorothy Kosinski strongly supported this initiative through her leadership role on the Centennial exhibition and numerous other exhibition projects. Former Adjunct Curator María de Corral, who worked with the exhibition teams for *Fast Forward* and *Private Universes*, was an inspiration to us all in her commitment to finding new ways of looking at contemporary art.

Tamara Wootton-Bonner, Chair of Collections and Exhibitions, and the entire Collections and Exhibitions Division have supported the work of the curatorial and education teams as we implement the Framework for Engaging with Art. Changes in the interpretation and presentation of our collections and exhibitions have also been carried out by the Arts Network team, a cross-divisional group in charge of our new technology initiatives. Special mention must be made of Jacqui Allen, Gail Davitt, Ted Forbes, Homer Gutierrez, Jeff Guy, and Jessica Heimberg.

Judy Conner, Chief of Marketing and Communications, has been a devoted advocate of FEA research, experimentation, and implementation. Her pursuit of a creative and consistent brand for the institution and her leadership in effecting changes to visitor services programs have been essential to the success of FEA. Her team, especially Jill Bernstein, Mandy Engleman, Susan Ferraro, Ginan Kalenik, Queta Watson, and Rebecca Winti, skillfully carry out the work of communicating with the public, an activity that is shared on a daily basis by all the staff members and volunteers who greet and interact with our guests, whether in Visitor Services, Education, Membership, the Museum Store, Operations, or Security. Diana Duncan, former Director of Development, actively supported all aspects of the Framework for Engaging with Art, and Acting Director Linda Lipscomb continures this work, guiding fundraising and developing membership programs.

Many others outside the Museum have also been critical to this institutional change, including Kathy McLean of Independent Exhibitions, a consultant on the Center for Creative Connections; Peggy Burt, Paul vonHeeder, and Sarah Wicker of *latitude*, a division of the Richards Group; Michael Bierut and Abbott Miller of Pentagram; and David Resnicow and Juliet Sorce of Resnicow & Schroeder.

Of course, none of this work would be possible without the commitment of our trustees, friends, and donors. The Framework for Engaging with Art has received extraordinary support from our trustees since its inception—they powerfully sustain the vision of the DMA as a collaborative institution dedicated to bringing our collections and exhibitions to a broader and more diverse audience. To the DMA Trustees, especially Deedie Rose, Chair, and John Eagle, President, and the former Chairs and Presidents during the course of this project—Walter Elcock, Jeremy Halbreich, Tim Hanley, and Marguerite Hoffman—I offer my profound gratitude for their understanding of the importance of the research and its publication. As Co-Chairs of the Campaign for a New Century, Marguerite Hoffman, Catherine Rose, and the late Robert Hoffman demonstrated a passionate belief in our ideas. Their leadership role in the Campaign helped

ensure the future of the Center for Creative Connections and the Arts Network, as well as secure the endowment of our curatorial and education staffs. As a component of the Campaign, the farsighted gifts from The Meadows Foundation and The Allen and Kelli Questrom Foundation in support of the new design and programs for the Center for Creative Connections enabled many of the research studies with RK&A. Kelli and Allen Questrom have been supporters of the Center for Creative Connections from its inception and, through their foundation, have endowed the directorship of the Center and provided support for staff in evaluation and programming whose efforts activated the Center. Critical support for the Arts Network was provided by The Institute of Museum and Library Services and The Meadows Foundation. The multiyear funding for the Center for Creative Connections and the Arts Network allowed us to plan for the future, and encouraged creative thinking and new ideas. I would like to gratefully acknowledge all the donors to the Campaign for a New Century, which launched the Center for Creative Connections and the Arts Network.

The preparation of the publication *Ignite the Power of Art: Advancing Visitor Engagement in Museums* was a tremendous undertaking and required the enthusiasm, perseverance, and expertise of a very large team of people. I would like to recognize the many individuals who made this book possible.

Ellen Hirzy, whom I gratefully acknowledge as co-author of this publication, was unflagging in her devotion to this project. Over the course of several years, Ellen immersed herself in the work of the DMA and flexibly contended with ever-changing ideas, innovative experiments, and new studies, many of which were completed during the time that we were writing the book. It is a challenge to keep up with an institution that is in continual transformation, yet Ellen remained both constant and adaptable. I am also exceedingly grateful to Randi Korn for her thoughtful and tireless assistance in the editing and review of the text. For their support, passion, and belief in the work we at the DMA are doing, I cannot adequately express my appreciation.

This publication has been enhanced by the distinct voices of eight external members of our community, each of whom has offered a unique perspective on the changes that have occurred at the Museum. My thanks go to Gigi Antoni, Anne and Brent Brown, Marguerite Hoffman, Dennis Kratz, Veletta Lill, Lesli Robertson, and Harry Robinson.

Gail Davitt and Tamara Wootton-Bonner helped guide the manuscript through to publication with unfailing encouragement and enthusiasm. Their contributions as editors, fact-checkers, sounding boards, and cheerleaders made the completion of this book a pleasure. Eric Zeidler, Publications Coordinator, provided unsurpassed organizational skills throughout the course of the project, as did Giselle Castro-Brightenberg, Manager of Imaging Services, who compiled and organized the thousands of photographs that were made to illustrate the story. It is with deep gratitude that I acknowledge the many other Museum staff members who have contributed to the production of this book: Jacqui Allen, Carolyn Bess, Sharisse Butler, Judy Conner, Susan Diachisin, Mandy Engleman, Rachel Ferraro, Brad Flowers, Diane Flowers, Ted Forbes, Adam Gingrich, Homer Gutierrez, Jessica Heimberg, Elaine Higgins, Molly Kysar, Linda Lipscomb, Stacey Lizotte, Virginia Olson, Chad Redmon, Nicole Stutzman, Kevin Todora, Queta Watson, and Rebecca Winti.

Editor Lucy Flint provided a careful and sensitive review of the manuscript and helped shape the story's narrative. Designer Greg Dittmar imaginatively conveys the energy of our work in his creative design. To both I express my thanks for capturing the excitement of the changes at the DMA. I am especially pleased that this book will be brought to a larger audience through our partners at Yale University Press, and I wish to acknowledge Patricia Fidler and Lindsay Toland for their key roles.

Finally, David Gelles, my son, and Mary McDermott Cook, my friend and a trustee of the DMA, gave me constant encouragement and support throughout the years of research and writing. I am profoundly grateful to both of them for their patient listening and rigorous thinking. Without them, the book would not have been completed.

In this book we explore the context for the Framework for Engaging with Art, present research findings, and highlight the changes we are seeing throughout the Museum—in our relationships with our visitors, with people and organizations in our community, and with one another. While this is a story about our work at the DMA, we would like to recognize similar achievements in many other museums. We have learned from our generous colleagues and been inspired by them as they explore possibilities for enhanced engagement with their audiences; we hope that this publication is useful to them.

On behalf of the staff, trustees, donors, and partners of the DMA, I am pleased to share this record of our transformation. The vision documented in this book reflects the creativity and commitment of a diverse community of people who have worked together over many years with one shared goal:

to ignite the power of art.

CHAPTER 1

IGNITING THE POWER OF ART

WHY WE DEVELOPED
THE FRAMEWORK FOR
ENGAGING WITH ART

To understand the impact of the Centennial, it is useful to know something of the Museum's past. The Dallas Museum of Art was founded in 1903 as the Dallas Art Association by a dedicated group of art lovers who began acquiring art and holding exhibitions in the public library. One hundred years later, the Museum continued to have generous local supporters and sustained a commitment to making art available to as many people as possible. Yet after a decade of declining revenues, and with a relatively modest annual attendance of 337,000 visitors, the Museum was underperforming.

When John R. Lane became The Eugene McDermott Director in 1999, he saw the urgent need for a revitalized mission and an outlook to match. He and the Board of Trustees set a five-point agenda: to animate the encyclopedic collections; elevate the modern and contemporary art collection and program to international stature; restore the Museum to the national and international exhibition circuit; establish the Museum as a national leader in arts learning and public and community programming; and build a stable base of endowment and other financial resources. In 2000

Jack Lane invited Bonnie Pitman to join the Museum as Deputy Director, and over the next eight years they worked together with the entire staff to transform the institution into a major art museum with rapidly growing collections, thoughtfully and dynamically engaged with its community.

Walking through the galleries around that time, it was impossible not to notice how few visitors there were. The Museum had so many assets: extraordinary art from ancient to modern times, stimulating exhibitions and programs, and the energetic contributions of dedicated donors, trustees, staff, and volunteers. We realized that the only way to find out why it was not more of a destination for visitors was to ask them. Like many museums, the DMA had used audience research successfully, but we had applied it mostly to program and exhibition evaluation or marketing. This time our research would have a more expansive purpose and scale. By understanding the nature of visitors' experiences with art, we wanted to spark their creativity, curiosity, and wonder and inspire other visitors to join them.

As a prelude to this research, during 2001 and 2002 we held forums with more than 450 people throughout the Dallas region to learn what our community did and did not know about us. Most who were familiar with the Museum had positive responses, but others were not very interested in the programs and experiences we offered. Some felt the Museum was not hospitable, and some considered it slightly depressing: One local resident suggested that the acronym DMA stood for Dallas Mortuary Association, and another participant referred to the institutional logo as a "black box."

We wanted to overturn these perceptions by forging a dynamic and inclusive identity and improving our engagement with the community. To begin, we needed the entire staff to value the visitor. Everyone—from curators to educators to visitor services and security staff—would have to join forces to spur change. With this gradual shift in our working culture, we needed to reconsider all aspects of our work: staff structure, processes, collaboration, and training. It would be demanding, but the resulting creativity, experimentation, and innovation would be worth the effort.

A Revitalized Mission and Brand Identity

The DMA Board of Trustees and staff began by writing a mission statement that would signal new energy and new priorities. It replaced the statement that had served since 1995:

The Dallas Museum of Art is a public art museum that collects, preserves, presents, and interprets works of art of the highest quality. The successful pursuit thereof will guarantee a place among the nation's preeminent art museums for the DMA, whose broad collections of great quality and innovative educational programs earn the respect, support, and affection of its public.

The revised mission statement of 2002—reaffirmed in 2010—is directed explicitly to visitors and their experience with art:

We collect, preserve, present, and interpret works of art of the highest quality from diverse cultures and many centuries, including that of our own time.

We ignite the power of art, embracing our responsibility to engage and educate our community, contribute to cultural knowledge, and advance creative endeavor.

Mission statements reflect and propel an institution's identity and the community's perception of it. The Museum responded to the critique voiced during the forums by initiating a branding and identity process that would shift its image from bland to bold, to describe a dynamic place everyone would want to visit and experience. Staff and trustees again worked together closely to examine every aspect of our identity—from the way visitors perceived our entrances to the visuals in our signage, publications, and marketing and advertising venues. The result was a new mission and positioning of our brand: "*To ignite the power of art through engaging experiences.*"

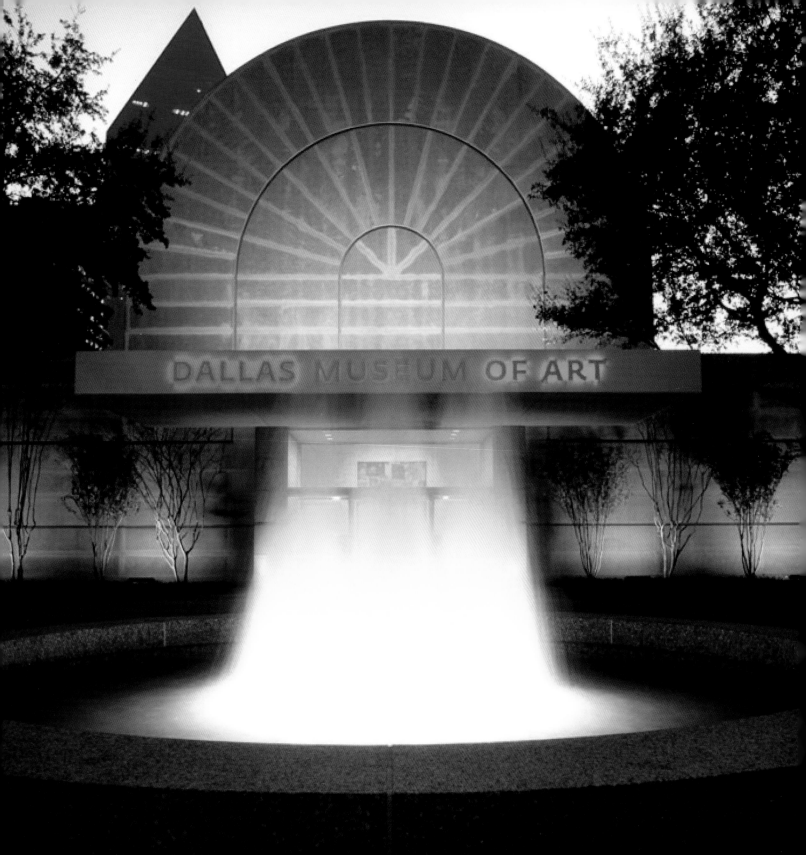

The result was a new mission and positioning of our brand:
"To ignite the power of art through engaging experiences."

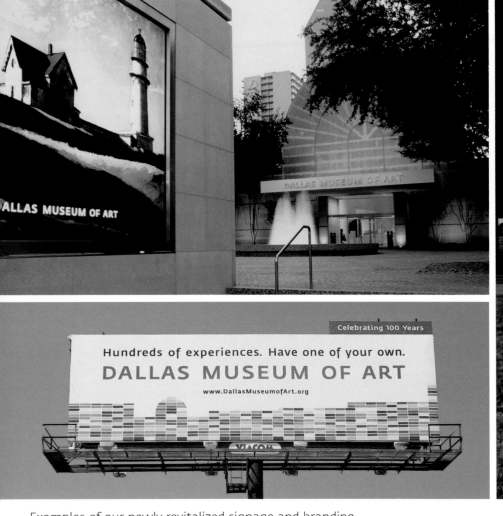

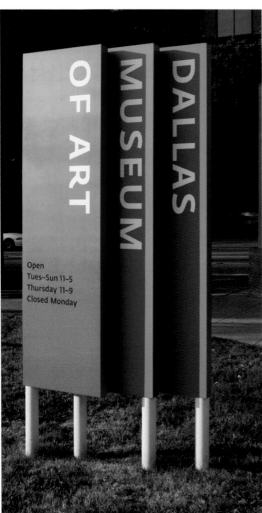

Examples of our newly revitalized signage and branding

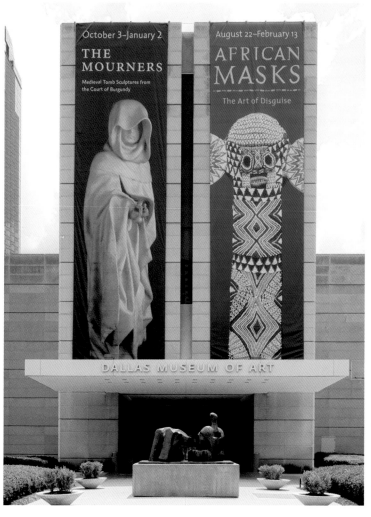

Evolution of the Framework for Engaging with Art

During the summer of 2001, staff from the Curatorial, Education, Marketing, and Development Divisions met to discuss what information we needed to better understand visitors beyond the usual demographics of gender, age, race and ethnicity, education, and income. This intensive dialogue, which often became spirited debate, indelibly informs the Framework for Engaging with Art.

We agreed our work together would have certain defining elements:

Mission
We would remain true to the Museum's expressed reason for being.

Excellence
We would be driven to achieve the highest quality at all times, in every aspect of the Museum.

Art
We repeated the phrase "it's all about the art" as a reminder that our goal is to engage visitors in looking at, enjoying, and learning from the collections and exhibitions. A focus on the works of art, artists, and creativity is central to all we do.

Audience
We wanted to intensify our understanding of current visitors as well as the visitors we hoped to attract so we could do a more effective job of engaging and serving a broader range of people

Research

We would incorporate audience research into the ongoing planning of exhibitions, programs, and marketing.

Experimentation

We would try out new ideas across the Museum, in exhibition and program development, interpretation, marketing and communications, evaluation, visitor services, and security. Our attitudes and behaviors would remain fluid.

Collaboration

We would value the ideas and expertise of all divisions and departments, from curators who work with the collection and educators who involve visitors in learning experiences to marketing, development, and membership staff who generate visibility and support for all activities. We would also actively strengthen our partnerships in the community.

Based on our assumptions about different types of visitors and their backgrounds, interests, and learning styles, we identified three levels of engagement with art (Awareness, Appreciation, and Commitment), each with preferred types of experiences. After considerable debate and discussion, we decided to test our assumptions using a series of exhibition experiments and then apply what we learned to the aesthetic, educational, and social experiences we created for visitors.

Early Experiments

More aware of the divergent relationships people have with art, we began to explore what it would mean to think about visitors' characteristics from the moment an idea for an exhibition or program was conceived, instead of later in the process. The exhibition *Renoir and Algeria* in 2003—presenting 50 works by the impressionist master that show the influence of North African culture—was a key opportunity for testing the potential impact of this approach on public programming.

A cross-divisional planning team looked at the exhibition's content and determined the primary target audience to be those who had only "awareness" of the Museum and little or no knowledge of art. Following a typical pattern, curatorial advocates proposed an all-day symposium involving prominent scholars, while program advocates argued for events designed for the main target audience. Our visitor research was just beginning, and the events that were planned served both agendas. Two pilot programs called Impressionist Evenings were conceived by a partnership of Education and Membership staff to help recruit new members. The programs attracted more than 4,000 visitors who viewed the exhibition, took

Twilight Tours of the galleries, and watched exhibition-inspired performances. The Museum also offered scholarly lectures on *Renoir and Algeria* for visitors who wanted more in-depth information and analysis, and created a new audio tour of the collections. Impressionist Evenings and the Centennial celebration prompted the introduction in January 2004 of Late Nights, when the Museum is open until midnight on the third Friday of the month for performances, concerts, readings, film screenings, tours, family programs, and other activities.

The Centennial exhibition *Passion for Art: 100 Treasures, 100 Years* was the launching pad for more radical change. Featuring 100 of the Museum's greatest treasures, presented in thematic groupings that provoked fresh associations and invited visitors to experience the works in new ways, the exhibition involved collaboration among nearly all departments. Accompanying programming included performances in the galleries and family activities.

"With *100 Treasures*, we began to see the institutional benefits of involving people in the Museum in different ways," says

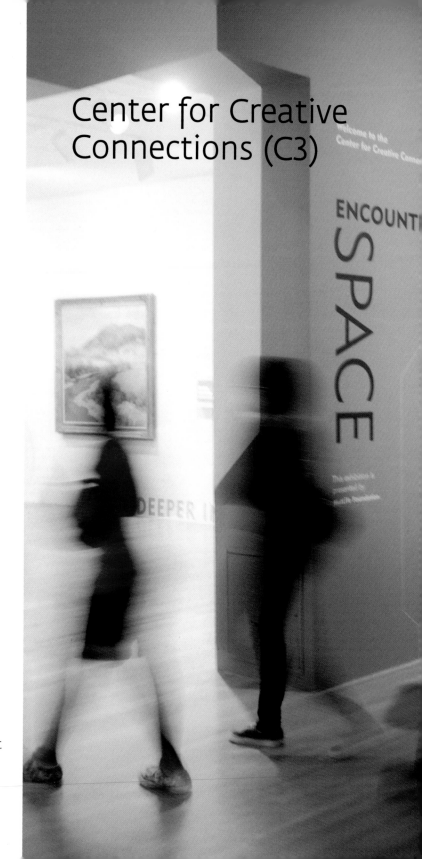

Center for Creative Connections (C3)

Dorothy Kosinski. The exhibition led us to make a bigger investment in creative risk taking. We experimented with text labels that were more concise and less academic in tone and often included photographs. We incorporated video with images and music but no narration. For the first time, writing and editing the exhibition interpretive text was a team process involving the exhibition curator, the educators, and the editor, and the text was signed by staff and members of the community.

During these early experiments, we realized that we needed systematic research about our visitors and their preferences. We entered a highly significant learning mode that is now part of the organizational culture. Soon after our exhibition experiments, we planned new initiatives that have contributed to noticeable changes in the ways visitors engage with art at the DMA: the Center for Creative Connections, an interactive environment that involves visitors in active learning about the collections; Late Nights at the Dallas Museum of Art, monthly evenings when the Museum is open until midnight with more than 20 exciting programs; and the Arts Network, an experiment with media in multiple formats, both online and in the galleries.

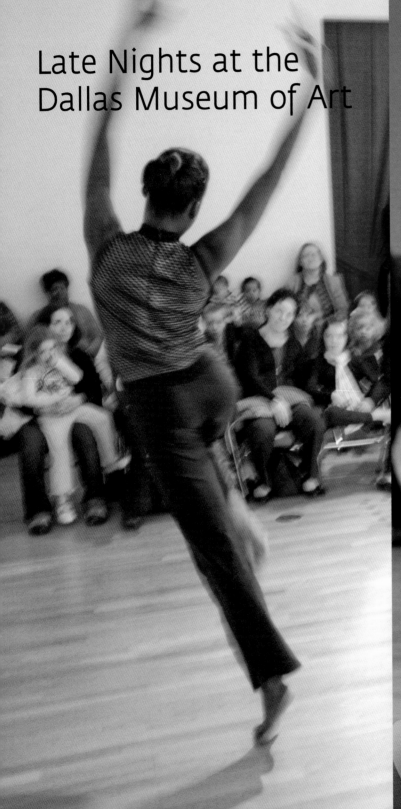

Late Nights at the Dallas Museum of Art

Arts Network

Launching Visitor Research

After this period of experimentation, we were ready to learn how well our framework for engaging with art aligned with our understanding of our audiences, and so with the museum planning, evaluation, and research firm Randi Korn & Associates, Inc. (RK&A), we began developing the first audience study. In an intensive six-month planning and design process, RK&A and a team of education and curatorial staff developed a questionnaire that included the 10 statements that became the basis of our research about visitor engagement with art (see page 39). Rather than focusing this research on the demographic profile of who came to the Museum or what perceptions visitors held of the institution, we would address what they valued about an experience in an art museum and, most important, how they made meaningful connections to works of art.

What distinguishes this research from other earlier DMA studies is its emphasis on visitors' *self-expressed* preferences and characteristics that describe complex relationships between a visitor and a work of art.

Studies that stress demographic distinctions and characteristics—such as age, gender, race and ethnicity, and income—can tell us only so much. Demographic characteristics are valid and important variables when conceiving of marketing strategies and when exploring people's motivations for visiting a museum (or learning what keeps them away). However, they reveal little about the ways in which visitors engage with works of art, and they do not necessarily help practitioners design programs and interpretation strategies. We were looking for the characteristics that would help staff create more assured and memorable experiences with art, with longer-lasting impact. At the same time, we were looking for information to help us translate those characteristics into more varied and more deliberate approaches. We acknowledged from the beginning that success would depend on a collaborative work environment. With appreciation for the challenge of shifting our own perceptions and daily practices on so many levels, we prepared to delve into the research.

COMMUNITY VOICE

A PEOPLE'S MUSEUM

Veletta Forsythe Lill
Executive Director, Dallas Arts District

Over the 25 years since my first visit to the Dallas Museum of Art, I've seen it evolve from a conventional museum to a people's museum. The DMA used to be a monochromatic place. Now it's a kaleidoscope of art, people, programs, and perspectives, and it's providing blueprints for other institutions.

When the Museum moved from Fair Park to the new Arts District downtown in 1984, it was the pioneer. Dramatic change was on the horizon. Now the District is a thriving cultural oasis, and the Museum's trustees and leadership have been key to its evolution. They were interested in developing both a world-class art museum and a museum with a closer relationship to its community.

It's hard to know now where to start describing the way that change has played out. Take the decision to redesign the Harwood Street entrance. After community forums showed that people found the Museum building cold, even a little intimidating, the Museum tore down a wall, reconfigured the entrance, and replaced the signage. These physical changes sent the message "We're open to everyone." I've noticed that the gallery attendants reinforce

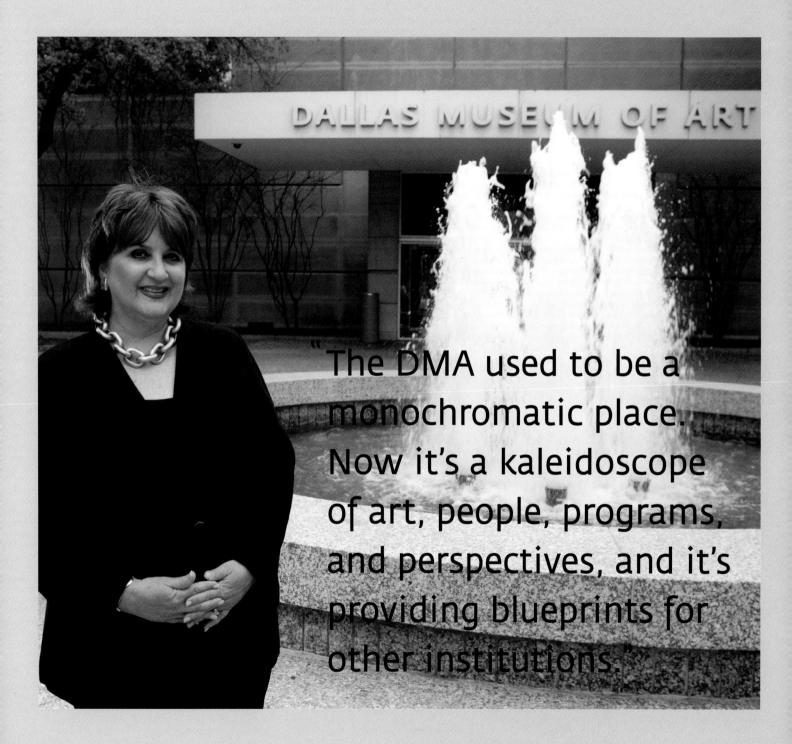

"The DMA used to be a monochromatic place. Now it's a kaleidoscope of art, people, programs, and perspectives, and it's providing blueprints for other institutions."

this message with their welcoming attitude toward visitors. Sometimes they'll share an observation about an artist or a detail about something that's going on in another part of the Museum. Those small gestures contribute to a more intimate, comfortable experience.

People still talk about the 100 Hours experiment during the Centennial. Since then, the DMA has thrown out the notion of the 11-to-5 museum. We're all working more hours, regardless of what we do for a living, especially in this economy. It's hard to find a moment to relax and spend time in a museum. By extending its hours on Thursdays and on monthly Late Nights, the DMA has become a place where people can socialize while enjoying art. You see couples on date nights, teenagers hanging out with their friends, and kids whose parents have brought them in their pajamas for a bedtime story with Arturo, the family mascot.

The Center for Creative Connections makes the Museum even more dynamic. So does the DMA's effort to attract a tech-savvy generation with new approaches like smARTphones in the galleries and a very active presence in social media. As an early adopter of Facebook, Twitter, and Flickr, the Museum has been the group we all want to emulate. In so many ways, the Museum's public programs have become more thought-provoking, self-directed, relaxed, and flexible.

The transformation continues with every exhibition. To celebrate the opening of the AT&T Performing Arts Center, *All the World's a Stage: Celebrating Performance in the Visual Arts* married the performing and visual arts to show visitors the cross-pollination among art forms. By

inviting (and employing) local artists as active participants, the Museum created stronger bonds with performing artists who would usually spend most of their time in the concert hall or onstage.

Tutankhamun and the Golden Age of the Pharaohs helped penetrate suburban audiences. It's hard to convince people to drive downtown, which can mean 60 to 80 miles in this sprawling region, because they don't have a big attachment to the city. Because of the broad appeal of Tut, the Museum attracted this niche, some of whom were first-time visitors. If they come once and have a good experience, they're likely to come again and enjoy all the amenities of the Arts District.

Collaboration and the leveraging of resources—which no organization has a lot of these days—are extremely important. The good news in Dallas today is that we have so many great arts institutions, and they all have leaders who value education and community engagement. It's the perfect nexus. You walk down Flora Street, the spine of the Arts District, and you realize what tremendous opportunities we have to collaborate on connecting people with the arts. Sharing these opportunities with a partner like the Dallas Museum of Art is a gift and a privilege.

"As an early adopter of Facebook, Twitter, and Flickr, the Museum has been the group we all want to emulate."

UNDERSTANDING HOW VISITORS ENGAGE WITH ART

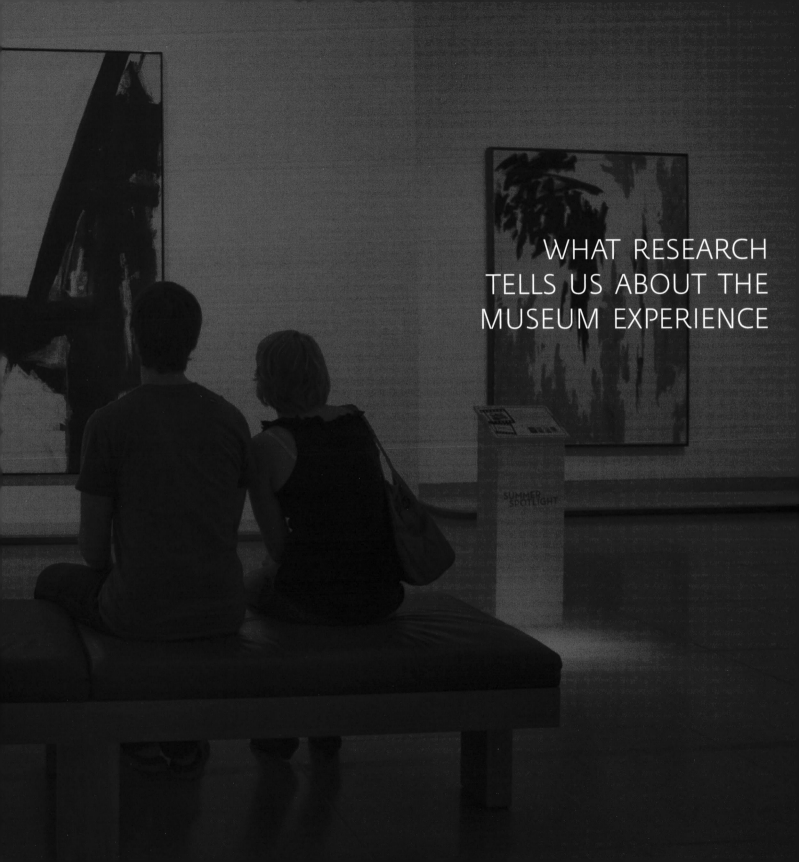

WHAT RESEARCH
TELLS US ABOUT THE
MUSEUM EXPERIENCE

Even a casual observation of visitors in the Dallas Museum of Art can reveal an intriguing variety of personal characteristics and behaviors.

In one gallery, a parent and child talk about Frederic Edwin Church's painting *The Icebergs*, admiring the icebergs' monumental scale and power. In the special exhibition *Private Universes*, a solitary visitor is enveloped by the gilded canvases of contemporary artist Jim Hodges's freestanding work *and still this*. In the interactive Center for Creative Connections, three teenagers write poetry in response to Janine Antoni's chocolate and soap sculpture. In the performance space for the exhibition *All the World's a Stage*, a group of friends enjoy a flamenco troupe inspired by John Singer Sargent's *Study for "The Spanish Dancer."*

Each of these visitors is uniquely wired to experience art in a different and personal way. How could we find out more about that "wiring" so that we could create more diverse and effective avenues to meaningful experiences with art? Once we recognized that a complex and hidden set of interactions occurs every time someone views a work of art, we began to look at our enterprise in a much more nuanced way. We proposed a research framework that is specific to the Dallas Museum of Art, designed around the preferences and characteristics of visitors that influence their relationships with art, art museums in general, and this museum in particular. We intended for this framework to guide our planning, program development, and marketing; it would become an institution-wide way of working together. If we understood more about all our visitors—including online visitors and teachers who come with their students—then we could create a museum environment based on this understanding that would involve visitors in more dynamic ways of looking at and experiencing art.

The research objectives of the FEA studies were to:

* explore visitors' art-viewing preferences quantitatively and qualitatively
* identify visitor clusters, or visitor types, based on visitors' art-viewing preferences
* explore visitor clusters quantitatively within the Framework for Engaging with Art
* explore visitors' preferences for meaningful experiences with works of art
* identify art background and demographic characteristics of visitors

Over seven years Randi Korn & Associates, Inc., worked with DMA staff led by Gail Davitt, Chair of Learning Initiatives and The Dallas Museum of Art League Director of Education, to conduct six visitor studies:

* Three onsite visitor studies with 1,536 visitors (2003/05 and 2008)
* A teacher study with 450 K–12 educators (2007)
* Two online visitor studies with 1,408 participants (2008 and 2009)

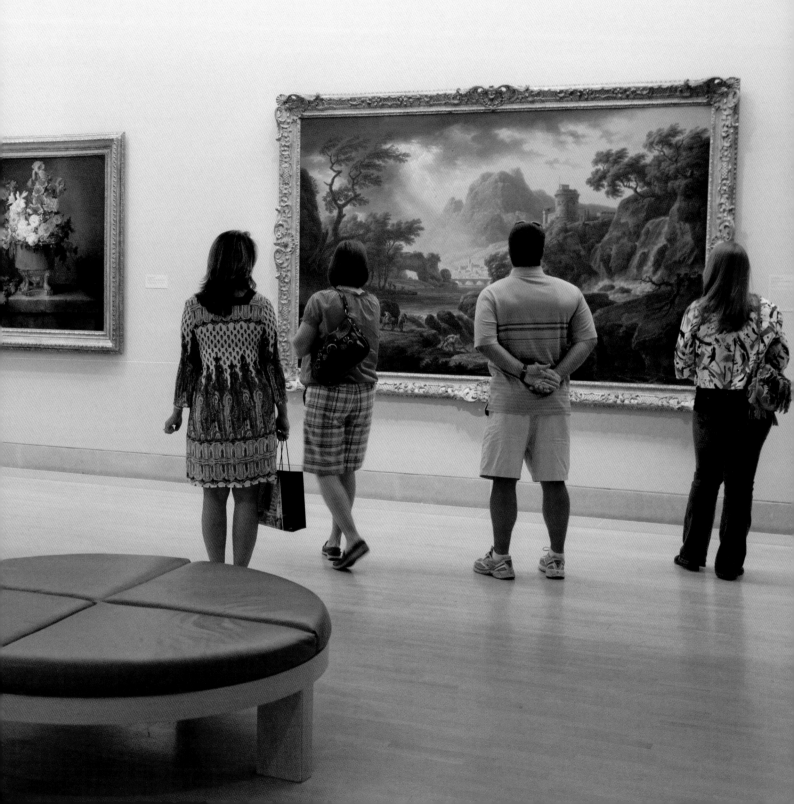

3
onsite visitor studies
1,536 visitors (2003/05 and 2008)

1
teacher study
450 K–12 educators (2007)

2
online visitor studies
1,408 participants (2008 and 2009)

This publication presents significant findings of the DMA studies and the Museum-wide changes in process and programs that we introduced to enhance visitors' experiences with art. In addition to the findings examined here, the research reports prepared by RK&A explored the characteristics of first-time and repeat visitors, members and non-members, local and non-local visitors, family groups and adult groups, females and males, and people of different ages. Available online at http://DallasMuseumofArt.org/FEA, the complete audience research reports contain a wealth of information that continues to inform our work.

It should be noted that we originally called our framework Levels of Engagement with Art and identified three levels: Awareness, Appreciation, and Commitment. As we worked with the research findings, we realized that the word "levels" might imply a hierarchy through which visitors progress. This was not our intention, nor did the research suggest such a progression. We revised the name to Framework for Engaging with Art, the term we use throughout this book.

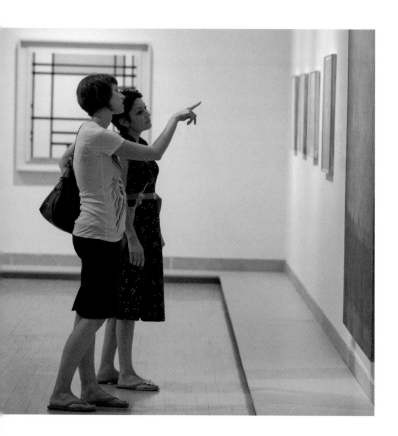

Launching the Research

The objectives of the research—to learn about preferences and characteristics of DMA visitors in relation to art experiences—shaped the conceptualization and wording of a standardized questionnaire and the analysis that followed. The first step was to prepare statements that visitors would rate according to their self-perceptions. RK&A advised using a 7-point scale that ranged from 1 (does not describe me) to 7 (describes me very well). Of all aspects of the research, formulating these statements was the most challenging. After intensive discussion, review, pre-testing with visitors, and revision, the DMA and RK&A settled on 10 distinct statements. As part of a larger standardized questionnaire that RK&A designed and refined in collaboration with the DMA, these statements became the crux of the research.

STATEMENTS ABOUT ART-VIEWING PREFERENCES

1. I feel comfortable looking at most types of art.

2. I like to know about the story portrayed in a work of art.

3. I like to know about the materials and techniques used by the artist.

4. I enjoy talking with others about the art we are looking at.

5. I am emotionally affected by art.

6. I like to be told a straightforward insight to help me know what the work of art is about.

7. I like to view a work of art on my own, without explanations or interpretations.

8. I am comfortable explaining the meaning of a work of art to a friend.

9. I like to connect with works of art through music, dance, dramatic performances, and readings.

10. I find some terms used in art museums difficult to understand.

In the first, two-phase study (2003/05), data were collected using a continuous random sampling method. Trained data collectors intercepted adult visitors 18 years of age and older as they were leaving the Museum, invited them to participate in the study, and verbally administered the questionnaire to those who agreed to participate. Respondents completed the last page of questions, which were demographic in nature, on their own.

In the 2003/05 study, 1,120 questionnaires were completed onsite, with a response rate of 64 percent. In the 2008 study, 416 surveys were completed onsite, with a response rate of 47 percent. The 2003/05 study was conducted during a period when exhibitions and programs were attracting a young and diverse audience. For the 2008 study, we deliberately readministered the survey while *J. M. W. Turner* was on view because we expected the exhibition to attract a more traditional art museum audience. We wanted to learn if the clusters and the Framework would hold, and they did. In both studies, the demographic profile of those who declined to participate (we recorded their gender and age) was statistically similar to the profile of those who agreed to participate, an important point in determining whether each sample is demographically representative of the DMA audience during the times the studies were conducted. In the 2008 study, 38 in-depth qualitative interviews were also conducted to complement the quantitative data collected through the questionnaire. The response rate of this data set is 85 percent. The interviews provide a more in-depth understanding of how visitors construct meanings from interactions with works of art. The descriptive data they yielded were analyzed for meaningful patterns, grouped as patterns emerged, and presented in narrative form in a report.

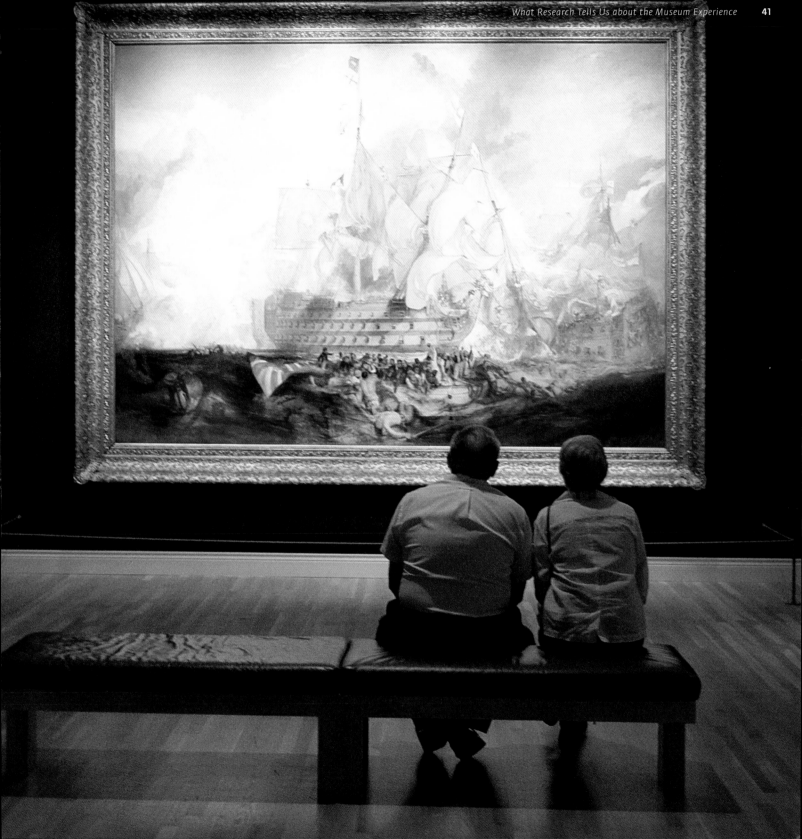

Visitor Clusters

With data from the questionnaires administered onsite in 2003/05 and 2008, RK&A conducted an analysis using a statistical procedure called K-means cluster analysis. In accordance with this procedure, RK&A directed statistical analysis software to organize onsite respondents into three, four, and five "natural clusters" based on visitors' ratings of the 10 statements presented in the questionnaire. The four-cluster grouping provided the most clarity for applying the results to daily work. Museum staff labeled these clusters Observers, Participants, Independents, and Enthusiasts according to their distinct characteristics, as indicated by their ratings. The data set from 2003/05 yielded these four clusters, as did the data set from 2008, despite the demographic differences between the two data sets. These results bolstered our confidence in the clusters as a meaningful construct for the DMA. It is important to remember that visitors' ratings of the 10 statements reflect their self-perceptions, and so the clusters indicate how visitors themselves feel about and understand their own engagement with art, no matter how others might rate them.

We describe each cluster on the following pages.

OBSERVERS

PARTICIPANTS

INDEPENDENTS

ENTHUSIASTS

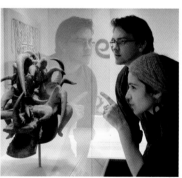

DMA VISITOR CLUSTERS

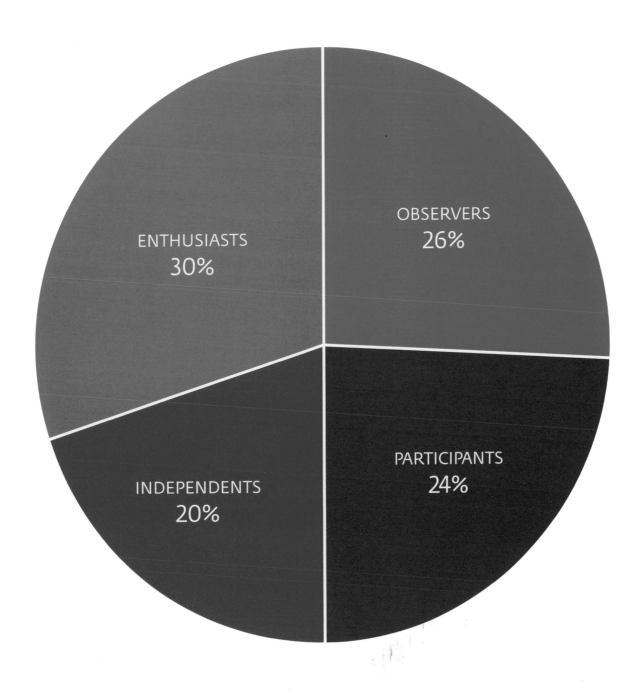

OBSERVERS
(26 percent of onsite visitors)

Observers are somewhat tentative about looking at art and being in art museums. Among the clusters, they are the least comfortable analyzing or talking about their experience of art, though almost half have some educational background in art and art history, and the majority stay informed on exhibitions and related events. Some Observers may be new to looking at art and visiting museums, as they do not recall in detail their experiences with works of art. But most return to the Museum after an initial visit, and their membership participation is similar to that of the more demonstrably engaged Participants and Independents.

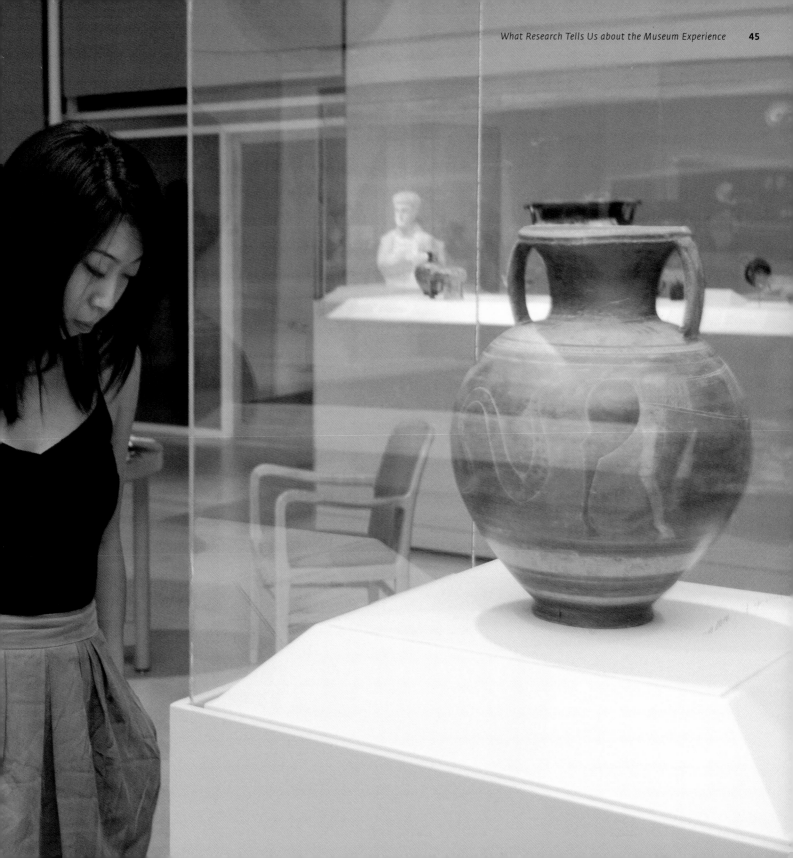

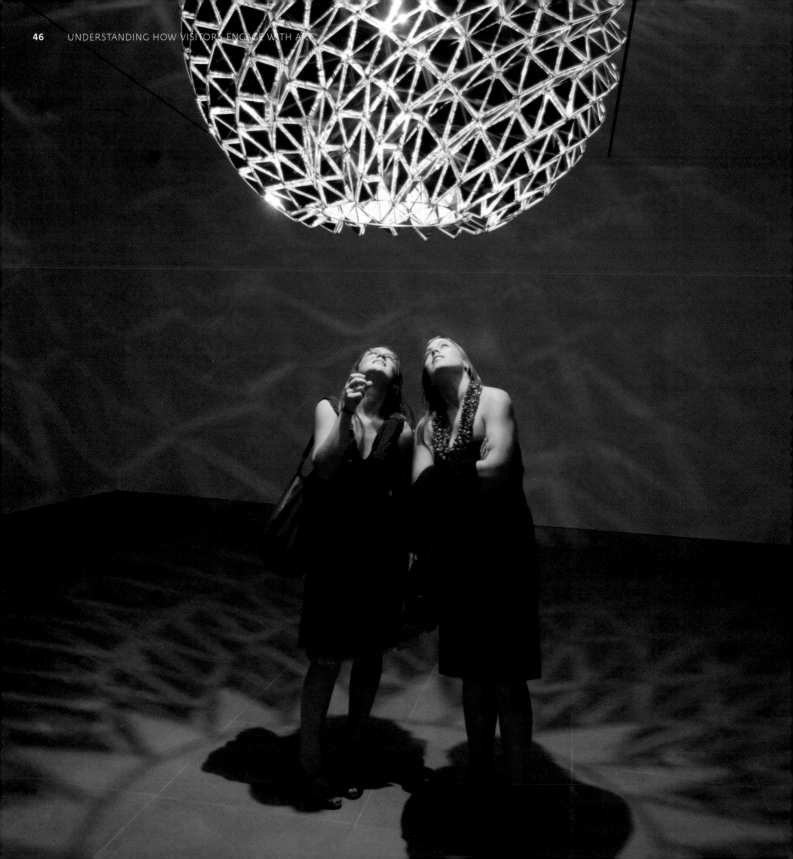

OBSERVERS

Select research data on the characteristics of Observers

48 percent have taken art history or art appreciation classes

19 percent have taken studio classes

4 percent describe themselves as artists

27 percent visit other cities to see art exhibitions

58 percent use the Internet to find out about art exhibitions and events

30 percent are first-time visitors

31 percent are DMA members

60 percent are male and 40 percent are female

OBSERVERS

Comparison with other clusters

Among the onsite visitor clusters, Observers include the highest proportion of males. While Observers express a moderate level of comfort looking at most types of art, their score for this statement is the lowest of the four clusters. Their more limited knowledge and understanding of art may affect their feelings about their overall Museum experience; among the four clusters, they rate it lowest. They are the least likely to visit museums or attend lectures and symposiums about art. However, their 31 percent rate of membership in the Dallas Museum of Art and other art museums is similar to that of Participants and Independents.

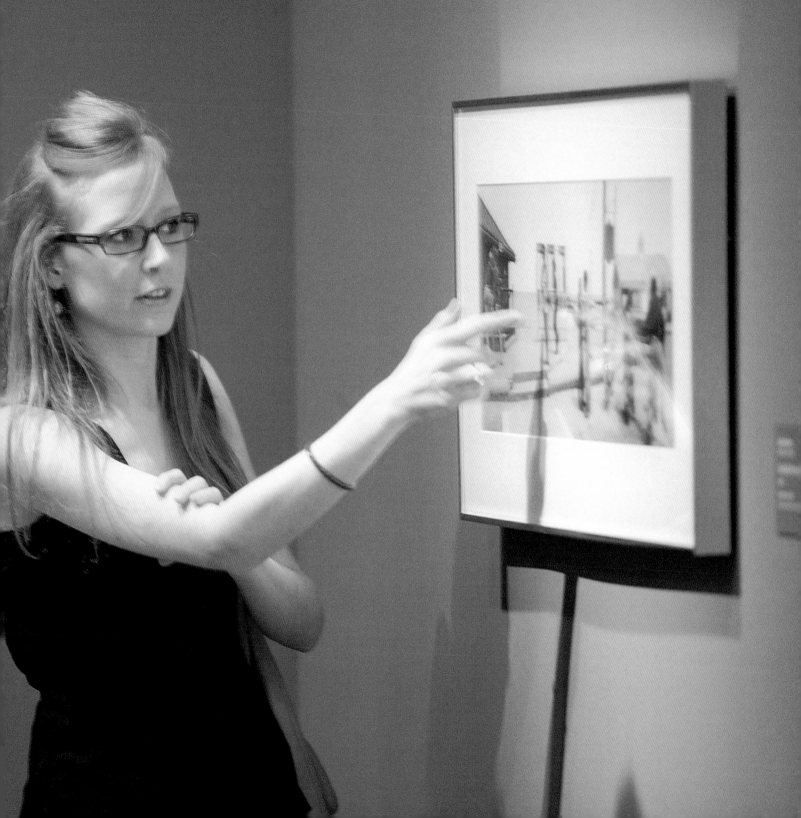

OBSERVERS

How the Museum can serve Observers

Enhance the physical aspects of their visit, such as parking, guest services, and security

Orient the visitor with clear wayfinding and introductory materials, both online and in the building

Provide introductions on how to look at art

Provide fun and entertaining experiences

Use straightforward language when communicating information about works of art

Emphasize the value and offerings of the DMA, encouraging participation with family and friends

Promote repeat visitation and membership, encouraging opportunities to learn the basics of art viewing

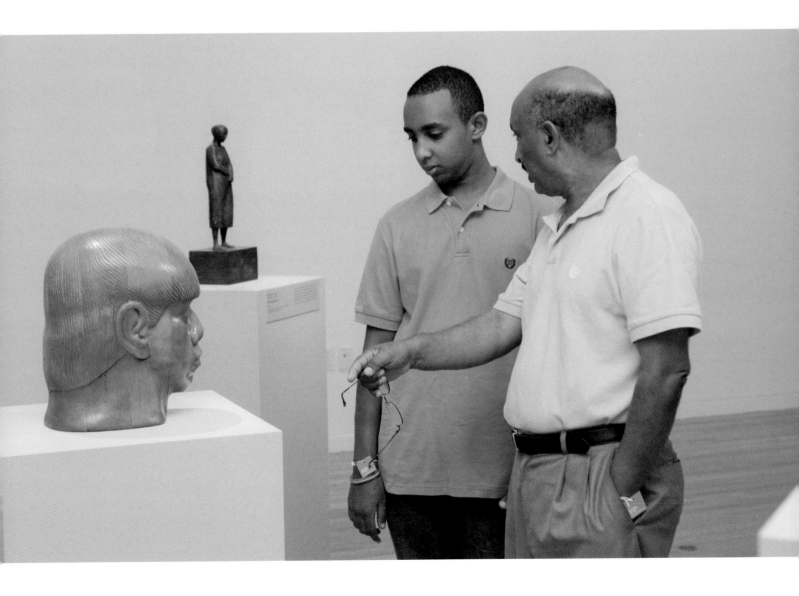

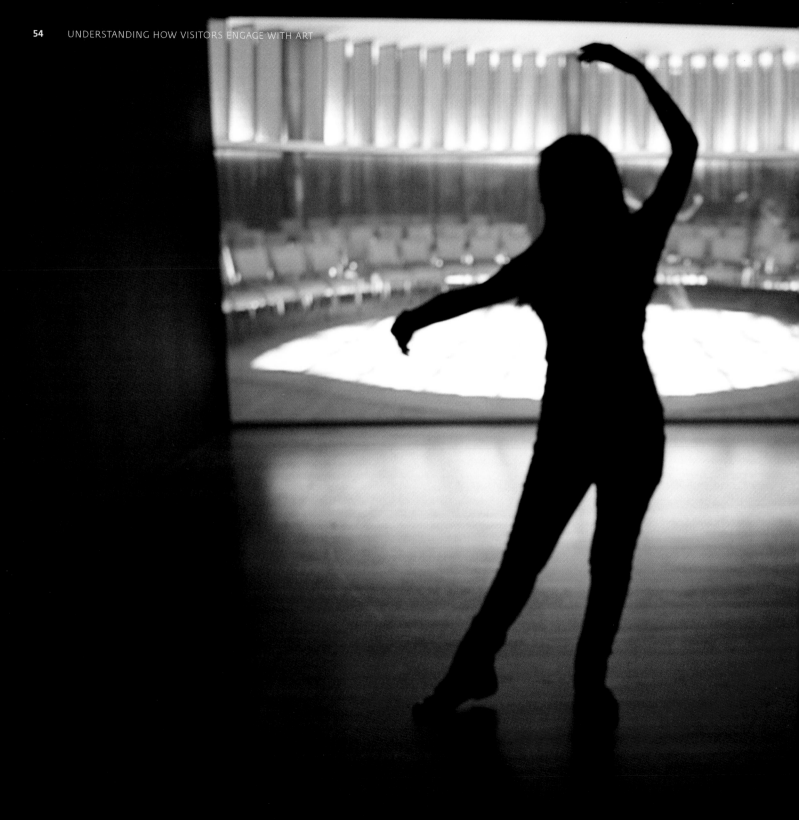

PARTICIPANTS
(24 percent of onsite visitors)

People in this cluster enjoy the learning and social aspects
of their experiences in art museums and are comfortable
looking at most types of art. They have a strong knowledge
of and interest in art, and they like to connect with works
of art through music, dance, dramatic performances,
readings, and a variety of other ways. Participants easily
provide thoughtful descriptions of what a meaningful
experience in an art museum is, value "real" works of art,
and actively use interpretive resources and programs.

PARTICIPANTS

Select research data on the characteristics of Participants

70 percent have taken art history or art appreciation classes

35 percent have taken studio classes

29 percent describe themselves as artists

48 percent visit other cities to see art exhibitions

76 percent use the Internet to find out about art exhibitions and events

30 percent are first-time visitors

33 percent are DMA members

38 percent are male and 62 percent are female

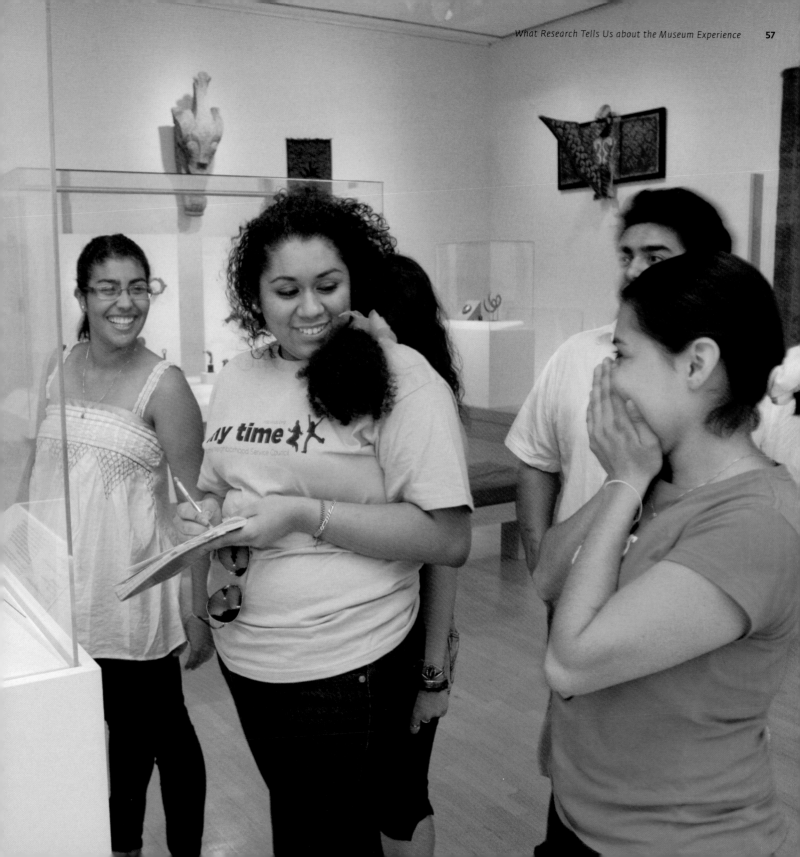

PARTICIPANTS

Comfort level with art

Participants have a solid art background, are active art consumers, and feel an emotional connection with art. While they are curious about and comfortable looking at most types of art, some visitors in this cluster have some difficulty with art terminology. Participants are emotionally affected by art, but not to the extent of Enthusiasts.

Interpretation preferences

Participants enjoy art and focus their experiences on learning; they use guided tours, consult resources in reading areas, and attend lectures and symposiums at the DMA and elsewhere. Of the four clusters, they are most enthusiastic about connecting with the visual arts through other creative arts, such as music, dance, and performances. Participants are interested in learning the story portrayed in a work of art, gaining straightforward insights about a work of art, and knowing about the artist's materials and techniques. During interviews, some indicated that they are aware that interpretive materials, lighting, and presentation affect their understanding of a work of art. Their preferences are reflected in the following data:

Program attendance

38 percent: Guided tours or gallery talks

25 percent: Lectures or symposiums

31 percent: Late Nights

28 percent: Jazz in the Atrium

12 percent: Concert series

14 percent: Arts & Letters Live

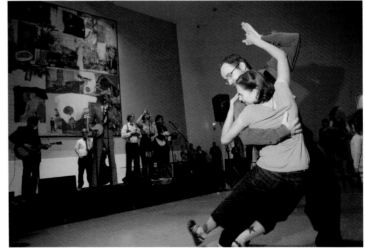

PARTICIPANTS

Comparison with other clusters

Participants have significantly more experience in art history, art appreciation, and art making than Observers. They are somewhat less confident about, emotionally connected to, and comfortable with art than Enthusiasts. Along with Enthusiasts, they are the most interested in talking with others about the art they are looking at. Of the four clusters, Participants have the strongest interest in connecting with works of art through music, dance, dramatic performances, and readings. They also like to take guided tours and use reading areas more than any other cluster. More Participants attend tours, gallery talks, lectures, and symposiums than Observers and Independents; they are second only to Enthusiasts. Ratings of their overall Museum experience are similar to those of Enthusiasts.

PARTICIPANTS

How the Museum can serve Participants

Create opportunities for social interaction and intellectual engagement with art

Use music, dance, and drama to encourage their creative connections and enhance interest in the visual arts

Offer opportunities for acquiring new skills in art making and creativity

Provide a variety of communication and program formats

Encourage visitors to bring friends to events and programs

Promote the social and learning value of repeat visitation and Museum membership

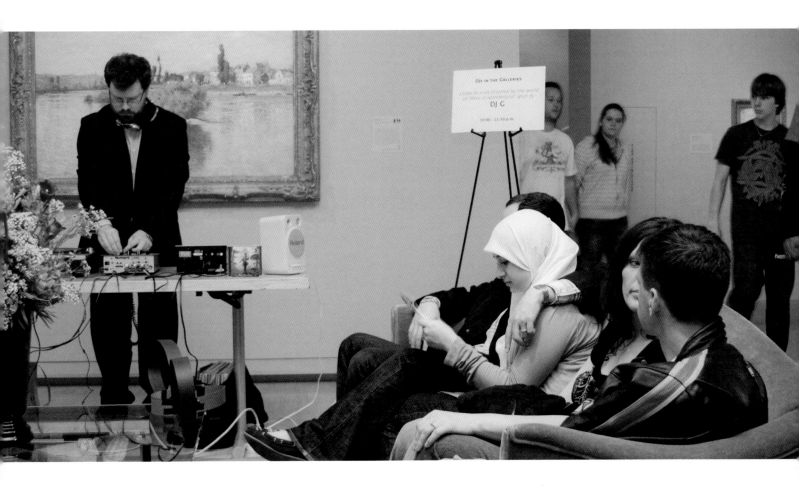

INDEPENDENTS
(20 percent of onsite visitors)

Independents like to view art on their own and develop their own explanations and interpretation. Their interactions with works of art are intense. They are confident about their art knowledge, have a strong educational background in art, and are comfortable with art terminology. They talk easily with others about art and have passionate responses to art. They feel the Museum needs to create a setting that encourages and allows visitors to slow down and look at works of art.

INDEPENDENTS

Select research data on the characteristics of Independents

73 percent have taken art history classes or art appreciation classes

41 percent have taken studio classes

32 percent describe themselves as artists

41 percent visit other cities to see art exhibitions

74 percent use the Internet to find out about art exhibitions and events

28 percent are first-time visitors

32 percent are DMA members

52 percent are male and 48 percent are female

INDEPENDENTS

Comfort level with art

Approaching the museum experience with a strong art background, Independents feel quite comfortable looking at most types of art. They are confident explaining the meaning of a work of art to a friend, and they identify strongly with the statement "I am emotionally affected by art." During the interviews, they easily gave thoughtful responses when asked to describe a meaningful experience in an art museum; they spoke of an intimate connection, whether emotional, immersive, or intellectual.

Interpretation preferences

Independents prefer viewing art and developing their own interpretations without being given explanations by the Museum. They like to know about the artist's materials and techniques, and they are less interested than other clusters in being told the story portrayed in a work of art. During the interviews, they strongly expressed the preference that museums create ways for visitors to slow down and look closely at works of art. They are not as interested in connecting with works of art through other modes of creative expression.

The preferences of Independents are reflected in the following data:

Program attendance

11 percent: Guided tours or gallery talks

24 percent: Lectures or symposiums

30 percent: Late Nights

39 percent: Jazz in the Atrium

6 percent: Concert series

14 percent: Arts & Letters Live

INDEPENDENTS

Comparison with other clusters

Forming the smallest segment of onsite visitors, Independents have the most balanced ratio of males to females of any cluster. Of the four clusters, Independents appear to be the most comfortable looking at art on their own and the least interested in being told straightforward insights intended to help them understand what they are viewing. About the same proportion of Independents attend lectures and symposiums as Participants—smaller than that of Enthusiasts, but larger than that of Observers. Nearly equal percentages of Independents, Participants, and Enthusiasts enjoy responding to art creatively. Independents score their overall Museum experience higher than Observers but slightly lower than Participants and Enthusiasts. Their rate of membership in the DMA and other art museums is similar to that of Observers and Participants and significantly lower than that of Enthusiasts. Independents and Participants visit art museums, including the DMA, with the same frequency.

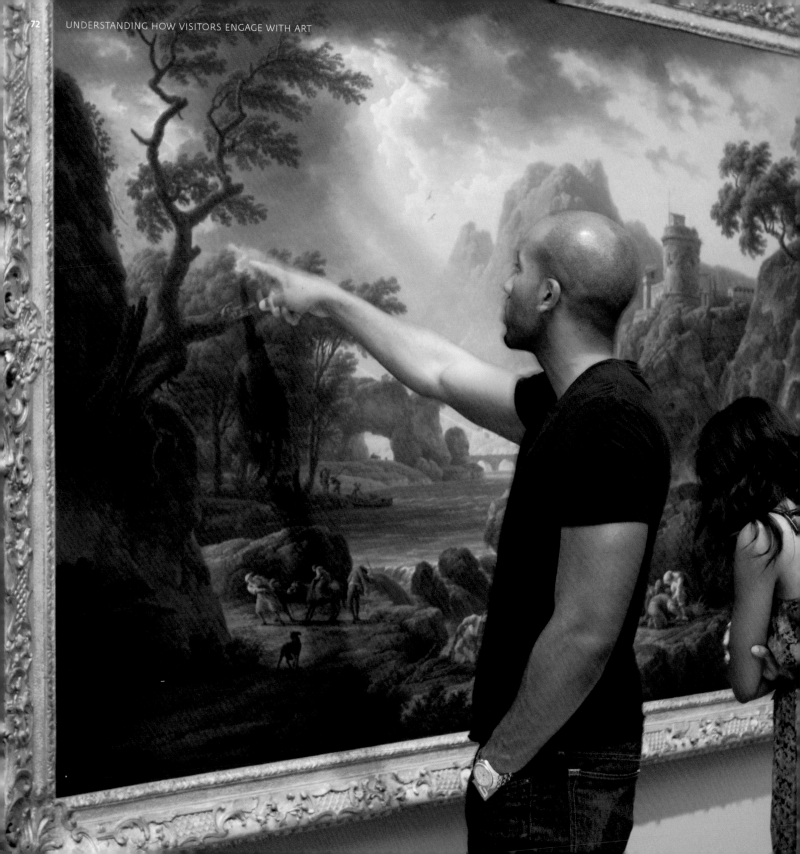

INDEPENDENTS

How the Museum can serve Independents

Create opportunities for Independents to experience works of art on their own without explanation or interpretation

Allow for freedom of choice in Museum offerings

Offer intellectual rigor in exhibitions and programs to increase specialized knowledge

Create settings that encourage close looking at works of art

Provide primary source information and opportunities to engage with artists and specialists such as collectors

Provide access to scholarly research

Promote Museum membership to deepen experiences and knowledge about art

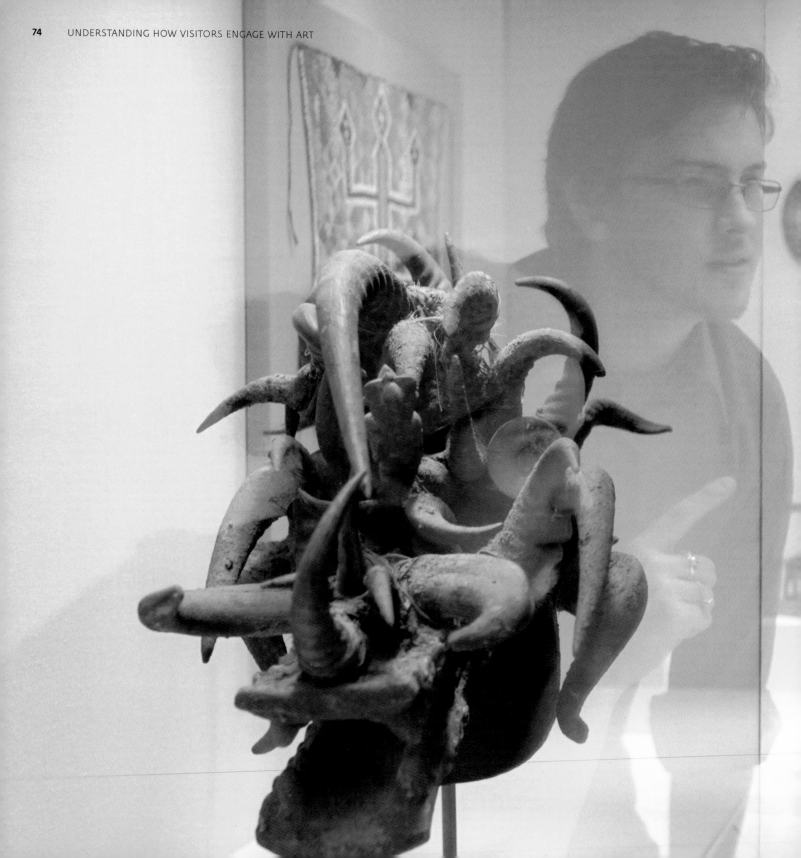

ENTHUSIASTS
(30 percent of onsite visitors)

Forming the largest segment of onsite visitors, Enthusiasts
are confident, knowledgeable, and enjoy looking at all
types of art. They connect with works of art emotionally,
both directly and through the performing arts. They
participate actively in a wide variety of Museum
programming and use interpretive resources in the
galleries. They have the strongest art background. They like
discussing the meaning of a work of art with friends, and
they are interested in the artist's materials and techniques.
Enthusiasts frequently visit the Museum and, among the
clusters, are the most likely to be members.

ENTHUSIASTS

Select research data on the characteristics of Enthusiasts

82 percent have taken art history or art appreciation classes

55 percent have taken studio classes

35 percent describe themselves as artists

66 percent visit other cities to see art exhibitions

83 percent use the Internet to find out about art exhibitions and events

12 percent are first-time visitors

50 percent are DMA members

25 percent are male and 75 percent are female

ENTHUSIASTS

Comfort level with art

Enthusiasts are very comfortable looking at and talking about art. They have experience in art history and art appreciation, and many have made art themselves. They understand the terminology of art museums and are not intimidated by it. They participate avidly in all offerings of museums and arts and cultural organizations: "More is never enough," according to one interviewee.

Interpretation preferences

Enthusiasts seek information of all types and in all formats. They are interested in knowing the story depicted in a work of art, receiving some insights to assist in interpretation, and learning about the artist's materials and techniques. They participate actively in guided and audio tours, lectures, and symposiums, enjoy responding creatively to art, and like connecting with art through music, dance, dramatic performances, and readings. More than half enjoy responding to art by creating art. Their preferences are reflected in the following data:

Program attendance

44 percent: Guided tours or gallery talks

38 percent: Lectures or symposiums

42 percent: Late Nights

37 percent: Jazz in the Atrium

21 percent: Concert series

26 percent: Arts & Letters Live

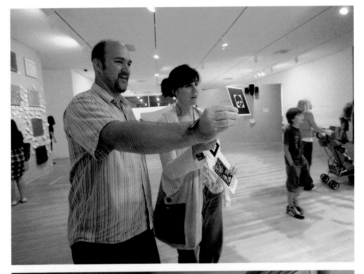

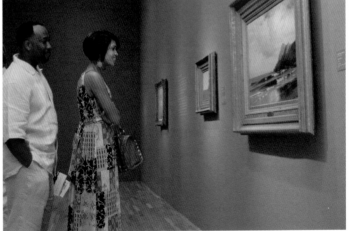

ENTHUSIASTS

Comparison with other clusters

Enthusiasts include the highest percentage of females of any cluster. They are the most emotionally affected by art and the most comfortable explaining works of art to a friend. More than any other cluster, Enthusiasts are interested in how art objects are made. They are second only to Participants in their interest in connecting with art through expressive modes like music and literature. Enthusiasts have the highest rate of membership at the DMA and other art museums (and almost all are repeat visitors); more than half visit art museums seven or more times annually. Ratings of their overall Museum experience are similar to those of Participants.

ENTHUSIASTS

How the Museum can serve Enthusiasts

Deepen knowledge and understanding of art history and creativity in dynamic programs and interpretation

Combine social interaction with learning

Offer a wide variety of interpretive formats, such as music, dance, and literature, in the galleries and as special programs

Link the Museum and works of art to life experiences

Encourage visitors to bring friends to events and programs

Create participatory experiences

Encourage increased membership levels, promoting opportunities to deepen their participation in DMA programs and special events

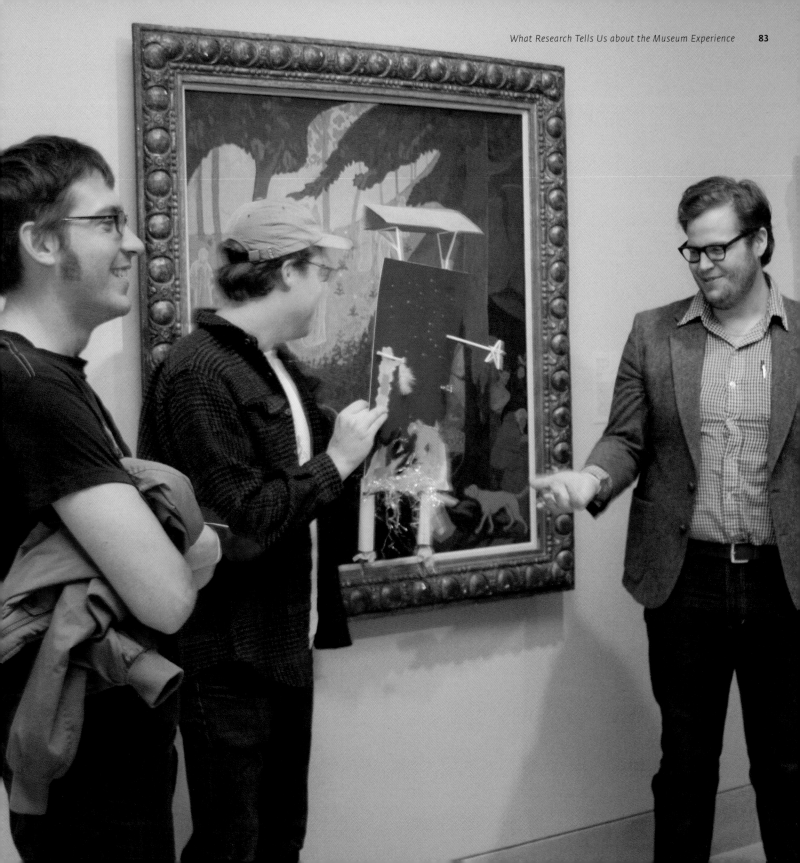

TABLE 1

RATINGS OF ART-VIEWING PREFERENCES BY CLUSTER

STATEMENTS ABOUT ART-VIEWING PREFERENCES Does not describe me (1) / Describes me very well (7)	Observers 26% *n* = 110 MEAN	Participants 24% *n* = 99 MEAN	Independents 20% *n* = 81 MEAN	Enthusiasts 30% *n* = 125 MEAN	Overall 100% *n* = 415 MEAN
I feel comfortable looking at most types of art.[1]	5.5	6.6	6.7	6.8	6.4
I like to know about the story portrayed in a work of art.[2]	6.0	6.5	4.7	6.4	6.0
I like to know about the materials and techniques used by the artist.[3]	4.6	6.1	5.1	6.3	5.7
I enjoy talking with others about the art we are looking at.[4]	4.5	6.3	5.9	6.3	5.7
I am emotionally affected by art.[5]	4.3	5.9	5.6	6.4	5.6
I like to be told a straightforward insight to help me know what the work of art is about.[6]	5.6	6.0	3.0	6.0	5.3
I like to view a work of art on my own, without explanations or interpretations.[7]	4.4	4.8	6.1	5.0	5.0
I am comfortable explaining the meaning of a work of art to a friend.[8]	2.9	5.2	5.1	6.1	4.8
I like to connect with art through music, dance, performances, and readings.[9]	3.0	5.4	4.2	5.1	4.4
I find some terms used in art museums difficult to understand.[10]	3.8	5.6	2.6	1.6	3.3

[1]$F = 39.912$; $p = .000$ | [2]$F = 49.997$; $p = .000$ | [3]$F = 36.656$; $p = .000$ | [4]$F = 55.651$; $p = .000$ | [5]$F = 48.675$; $p = .000$ | [6]$F = 121.533$; $p = .000$ | [7]$F = 16.645$; $p = .000$ | [8]$F = 100.621$; $p = .000$ | [9]$F = 44.874$; $p = .000$ | [10]$F = 210.542$; $p = .000$

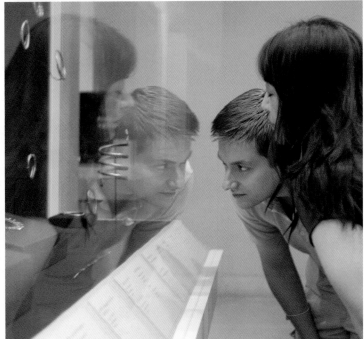

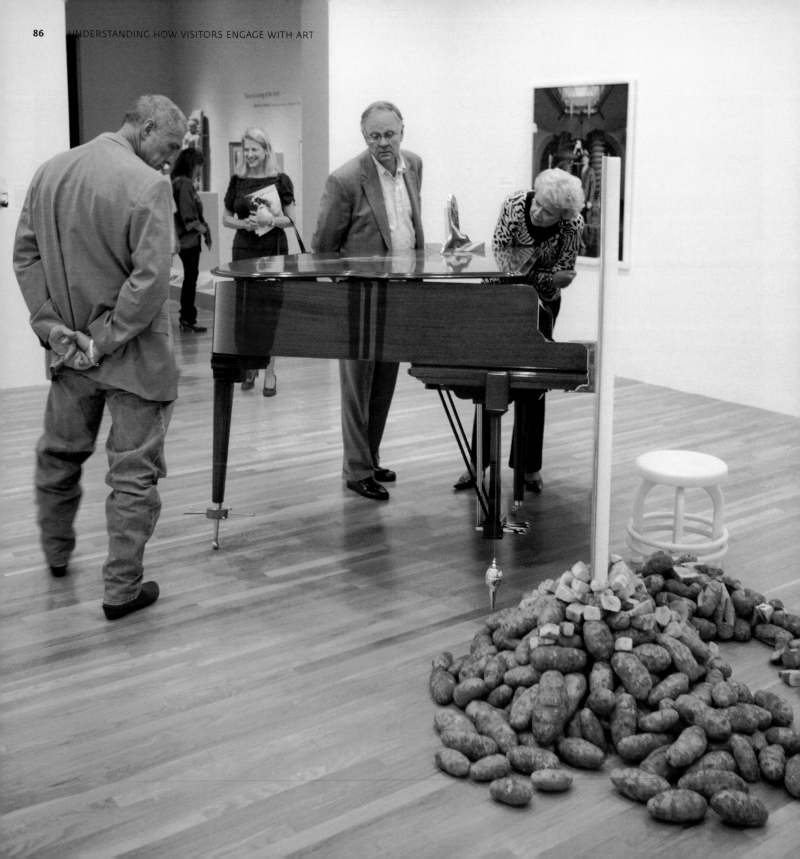

TABLE 2

BACKGROUND INFORMATION ABOUT VISITORS BY CLUSTER

ART-RELATED ACTIVITIES AND BACKGROUND	n	Observers	Participants	Independents	Enthusiasts	Overall
Has taken an art history or art appreciation class[1]	407	48%	70%	73%	82%	69%
Has taken 2 or more art history or art appreciation classes[2]	408	25%	50%	53%	68%	49%
Visited a city specifically to see an art exhibition in the past 12 months[3]	409	27%	48%	41%	66%	47%
Has taken studio art classes[4]	408	19%	35%	41%	55%	38%
Attended lecture or symposium in an art museum in the past 12 months[5]	409	14%	34%	20%	49%	31%
Is a practicing artist[6]	409	4%	29%	32%	35%	25%
Is a DMA member[7]	409	31%	33%	32%	50%	38%

[1] $X^2 = 30.642$; $df = 3$; $p = .000$ | [2] $X^2 = 42.639$; $df = 3$; $p = .000$ | [3] $X^2 = 33.817$; $df = 3$; $p = .000$ | [4] $X^2 = 31.647$; $df = 3$; $p = .000$ | [5] $X^2 = 38.335$; $df = 3$; $p = .000$ | [6] $X^2 = 34.545$; $df = 3$; $p = .000$ | [7] $X^2 = 12.680$; $df = 3$; $p = .000$

installed at the close of an exhibition, exploring related scholarship.

Visitor clusters also merge on Late Nights at the Dallas Museum of Art. We sometimes use Late Nights to target a particular cluster, while welcoming all visitors, as in 2009 when Summer Block Parties were designed to introduce Observers to the Museum.

Once we began to learn about our visitors in this new way, we started to wonder about other constituents, such as teachers and our online audience. Do teachers engage with art in the same way as walk-in visitors, or are there differences? How does their personal engagement with art museums relate to their professional engagement when teaching with art? Where do they fall within the clusters? And what about our Web users? Do they use the Web site to experience works of art? If so, what can we learn about them in the context of FEA? Our questions led us to extend our FEA research to teachers and online visitors.

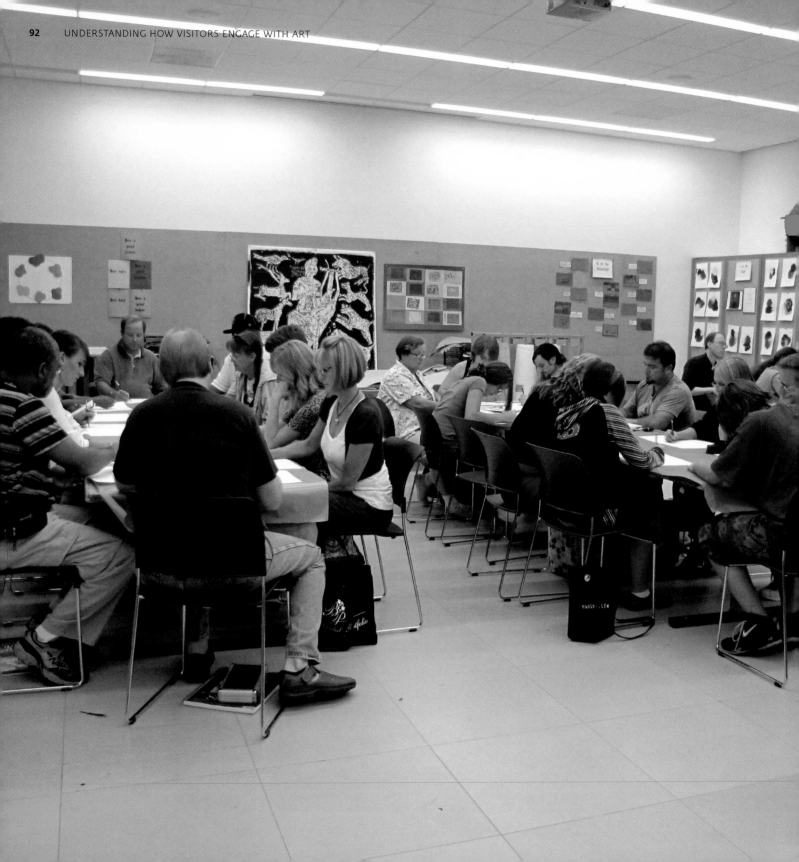

Teachers and the Framework for Engaging with Art

Each year, teachers in grades K–12 interact with the Museum through summer and in-service programs, teacher workshops, online teaching materials, and visits and learning partnerships with their students. In 2007 we conducted a study to learn how this special constituency fits into the Framework for Engaging with Art. We wanted to find out more about teachers as lifelong learners and as educators in order to address the questions posed.

The objectives of the teacher study were to:

- identify qualities and characteristics associated with different types of teachers in regard to their personal relationships with art

- identify qualities and characteristics associated with different types of teachers in regard to their professional training in art education and their use of art in classroom teaching

- explore how personal and professional characteristics determine cluster distributions

- identify factors that influence teachers' ability to take students on field trips to art museums

- identify touring strategies teachers use when they visit art museums with their students

Twelve hundred standardized questionnaires were mailed to teachers randomly selected from the DMA's database of educators. Of these, 472 were completed and returned, for a response rate of 45 percent. Later, 22 completed surveys were excluded because the respondents were not K–12 teachers, resulting in a final sample size of 450. In these questionnaires, teachers rated the same 10 statements presented to onsite visitors about their comfort with art and their needs and preferences for viewing it. In a separate question, using parallel wording, we presented 10 statements about how they teach with art in the classroom. These 10 statements, paired with the original statements, are as follows:

1. *I feel comfortable looking at most types of art. / I help my students feel comfortable looking at most types of art.*

2. *I like to know about the story portrayed in a work of art. / I tell my students about the story portrayed in a work of art.*

3. *I enjoy talking with others about the art we are looking at. / I encourage my students to discuss the art we are looking at with each other.*

4. *I am emotionally affected by art. / I encourage my students to explore how they are emotionally affected by art.*

5. *I like to know about the materials and techniques used by the artist. / I teach my students about the materials and techniques used by the artist.*

6. *I am comfortable explaining the meaning of a work of art to a friend. / I encourage my students to be comfortable explaining the meaning of a work of art to others.*

7. *I like to be told a straightforward insight to help me know what the work of art is about. / I give my students straightforward insights to help them understand what the work of art is about.*

8. *I like to connect with works of art through music, dance, dramatic performances, and readings. / I encourage my students to connect with works of art through music, dance, dramatic performances, and readings.*

9. *I like to view a work of art on my own, without explanations or interpretations. / I give my students time to view works of art on their own, without explanations or interpretations.*

10. *I find some terms used in art museums difficult to understand. / When discussing art with my students, I intentionally use art-related terms that may be difficult for them to understand at first.*

We used the results to better understand these important partners and more effectively support them (see pages 176-81).

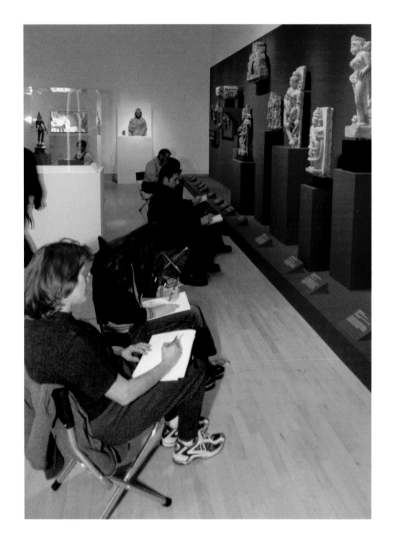

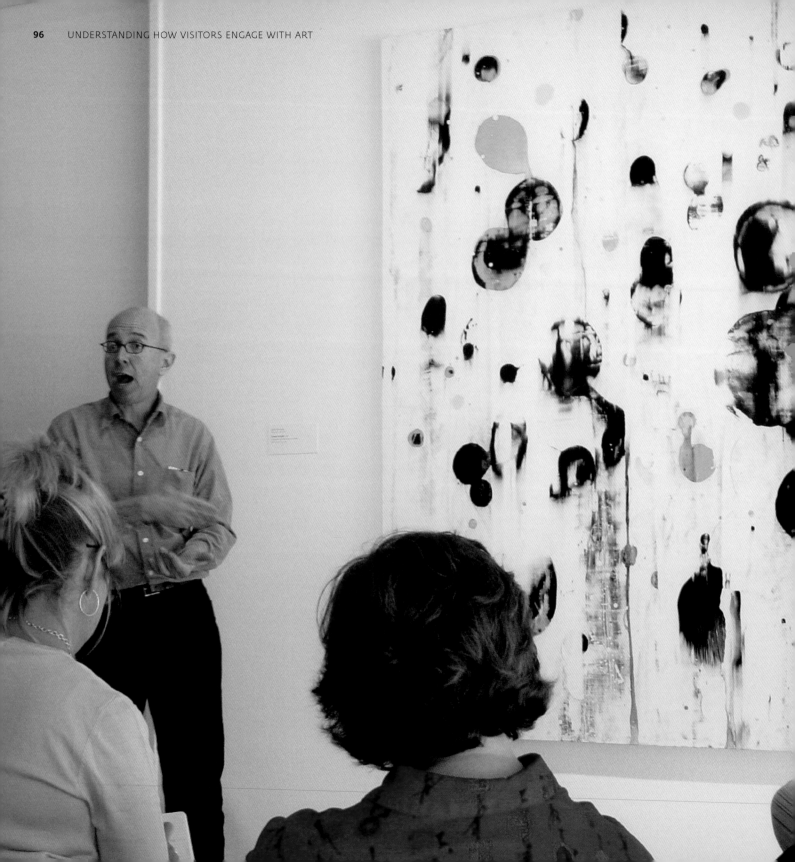

Select research data on teacher survey respondents

73 percent have more than 10 years of teaching experience, with a mean of 19 years

83 percent teach in public schools

44 percent teach in elementary schools, 11 percent in middle schools or junior high schools, and 34 percent in high schools; 11 percent teach in schools with mixed grades

49 percent are visual arts teachers, and 28 percent teach studio art only

54 percent of public and charter school teachers had attended a teacher workshop at an art museum in the past two years; 27 percent of teachers in private and parochial schools had done so

66 percent of visual arts teachers had attended a workshop at an art museum in the past two years; 33 percent of teachers in other disciplines had done so

they incorporate a variety of methods when viewing art with students. To teach African art, for example, they might combine videos of a masquerade performance, small group discussions on the themes of community or education in African art, a related studio project, and a visit to the DMA African galleries.

Like Independent teachers, Enthusiasts are comfortable with art and moved by it. They are highly knowledgeable about art and seek information through almost any means. Thirty-seven percent are members of the DMA. The activities they value most are reading wall text, attending gallery performances, taking guided tours, and listening to lectures or talks.

The teacher study brings to light many similarities and differences in educators as a Museum constituency, and is having a significant impact at the Museum. For more about how staff are using information gleaned from this research to rethink existing programs and create new ones, see Chapter 3.

TABLE 4

RATINGS OF ART-VIEWING PREFERENCES BY TEACHER CLUSTER

STATEMENTS ABOUT ART-VIEWING PREFERENCES Does not describe me (1) / Describes me very well (7)	Observers 23% *n* = 101 MEAN	Independents 30% *n* = 133 MEAN	Enthusiasts 47% *n* = 207 MEAN	Overall 100% *n* = 441 MEAN
I feel comfortable looking at most types of art.[1]	5.5	6.7	6.6	6.4
I like to know about the story portrayed in a work of art.[2]	5.3	5.3	6.5	5.9
I enjoy talking with others about the art we are looking at.[3]	4.2	6.1	6.5	5.8
I am emotionally affected by art.[4]	4.5	6.0	6.3	5.8
I like to know about the materials and techniques used by the artist.[5]	4.3	6.0	6.1	5.6
I am comfortable explaining the meaning of a work of art to a friend.[6]	3.6	6.3	6.1	5.6
I like to be told a straightforward insight to help me know what the work of art is about.[7]	4.5	4.4	5.8	5.1
I like to connect with art through music, dance, performances, and readings.[8]	4.2	3.2	5.7	4.6
I like to view a work of art on my own, without explanations or interpretations.[9]	4.1	5.4	4.1	4.5
I find some terms used in art museums difficult to understand.[10]	3.5	1.9	3.5	3.0

[1] $F = 57.196$; $p = .000$ | [2] $F = 52.559$; $p = .000$ | [3] $F = 155.856$; $p = .000$ | [4] $F = 69.751$; $p = .000$ | [5] $F = 61.576$; $p = .000$ | [6] $F = 198.451$; $p = .000$ | [7] $F = 47.197$; $p = .000$ | [8] $F = 104.664$; $p = .000$ | [9] $F = 26.770$; $p = .000$ | [10] $F = 44.957$; $p = .000$

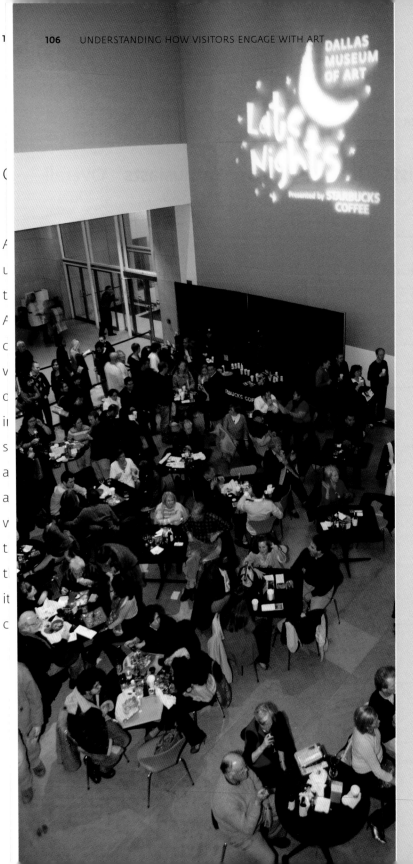

HOW PROGRAMS ENGAGE VISITOR CLUSTERS

Late Nights at the Dallas Museum of Art

Target Clusters: **ALL**

Once a month, the Museum is open until midnight to offer a smorgasbord of programs that visitors describe in interviews as "terrific," "exciting," "entertaining," "really fun," "cool," and "intriguing." Among the more than 20 programs offered on a given Late Night there is something for each visitor cluster—tours for Observers, performances for Participants, creative projects for Independents, and lectures for Enthusiasts. The 2009 Summer Block Parties, part of the Late Nights program, were especially designed to introduce Observers to the Museum, but we know that all types of visitors are attracted to Late Nights by the diversity of program choices and the opportunity to socialize with friends and new acquaintances.

Gallery Talks

Target Clusters: **PARTICIPANTS,** **INDEPENDENTS,** and **ENTHUSIASTS**

Gallery talks appeal to visitors with some art background who are eager for information and perspectives exchanged in the company of others. Artists discuss the creative process, art historians compare iconography across cultures, and curators talk about the development of an exhibition based on a theme. In preparation for gallery talks, Museum staff draw on FEA research to review visitor characteristics with speakers. Mindful of the difference between gallery talks and lectures, staff invite visitors to engage with the speaker and other visitors by asking questions, and they encourage speakers to allow time for discussion.

HOW PROGRAMS ENGAGE VISITOR CLUSTERS

Lectures

Target Clusters: **INDEPENDENTS** and **ENTHUSIASTS**

Lectures generally investigate works of art from the point of view of a specialist such as a visiting curator, author, scholar, or artist speaking about his or her own work. These programs are developed for art consumers with strong backgrounds in art history and studio art who are eager to hear these perspectives.

Films

Target Clusters: **OBSERVERS** and **PARTICIPANTS**

Popular films with broad appeal—such as *West Side Story* and *Moulin Rouge*, screened when the exhibition *All the World's a Stage* was on view—provide a variety of interpretive methods for interacting with art. Award-winning documentaries investigate connections between the visual and performing arts and allow visitors to enjoy film as an art form.

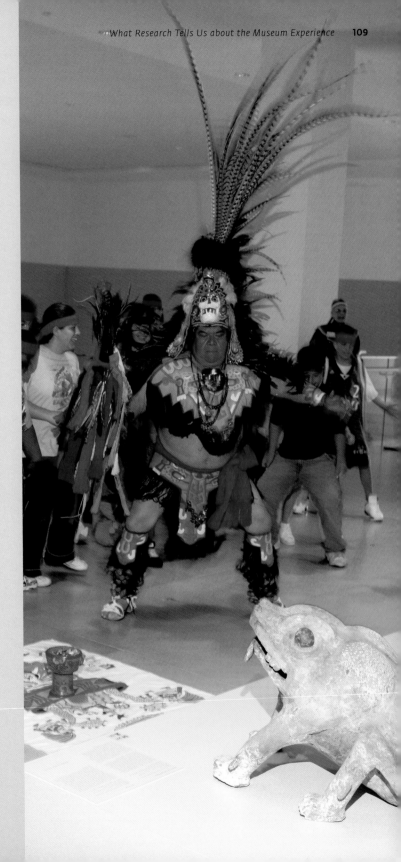

Performances in the Galleries

Target Cluster: **PARTICIPANTS** and **ENTHUSIASTS**

This program aims to connect visitors to art through music, dance, literary readings, and theater performances. We have learned that programs combining art forms can transform visitors' overall experience of the Museum, opening them to new possibilities. One visitor said, "The whole place seemed so alive, and I think that contributes to how you take things in when you sense that kind of energy level. And the music in the gallery with the art certainly contributed to that." Many who come to the Museum for other reasons have expressed their delight at happening on a performance while viewing art or taking a break in the café.

HOW PROGRAMS ENGAGE VISITOR CLUSTERS

Jazz in the Atrium

Target Clusters: **OBSERVERS** and **PARTICIPANTS**

Live jazz concerts on Thursday nights attract mostly Observers, who have little or no knowledge of art but enjoy a positive and entertaining experience, and Participants, who connect with the visual arts through other artistic expressions. Jazz performances are occasionally related to current exhibitions, and visitors are encouraged to view works of art after the show.

Gallery Interpretation

Target Clusters: **ALL**

The content and form of labels, audio tours, handheld devices (the DMA's smARTphone program), and computer programs vary according to the exhibition and, to a degree, the targeted audience. Informative labels might appeal particularly to Observers. An audio tour or smARTphone tour that presents interviews with collectors and artists supports Independents without giving them direct explanations crafted by the Museum. Likewise, being able to choose items from a menu on the smARTphone tour application gives Independents the option of reading primary sources rather than more general interpretive material. Participants and Enthusiasts might use a handheld Museum device to select a dance or interpretive sound design created by a choreographer or university student responding to a work of art. Enthusiasts are most likely to spend time at computers installed at the close of an exhibition, exploring related scholarship.

Putting the Framework for Engaging with Art into Practice

Our FEA research has helped us identify and learn about concrete indicators of meaningful museum experiences and how they may differ from one visitor cluster to another. We now know about visitors' preferences for interpretation of works of art, their interest in knowing about artists and their methods, and their comfort explaining a work of art to others. Across the four clusters we have a sense for how people react emotionally to art. We also have a better grasp of what kinds of information they need, how much, and how best to deliver that information.

Our challenge is to carefully balance how we apply our new knowledge about visitors to our daily work. As we use FEA to craft a holistic institutional strategy for engaging our visitors with art, we are conscious that knowing highly specific details about the four visitor clusters may tempt us to believe that we must serve all of them, all of the time. The beauty of the Framework, however, is in the flexibility it gives us to set goals for each cluster and keep those goals in mind as we work together toward a single institutional vision.

From the results of the visitor, teacher, and online studies to the implementation of research and evaluation, after eight years the Framework for Engaging with Art is embedded in our practice and in the way we think about our visitors. We now treat evaluation as essential organizational learning; a staff position supports ongoing evaluation of all aspects of visitor engagement, from the Center for Creative Connections to the Arts Network and to exhibitions, interpretation, and public programs. The next chapter describes practices, programs, and a dedicated experimental space in which we are addressing the Museum's goals for the four visitor clusters and the gradual implementation of the Framework for Engaging with Art.

COMMUNITY VOICE

SEISMIC SHIFTS, INSIDE AND OUT

Marguerite S. Hoffman

Trustee, Collector, and former Board Chair of the Dallas Museum of Art

The energy you feel when you walk into the Dallas Museum of Art today is 100 percent different than it was a decade ago. It has become a special place, close to the heart of our community. In the broader museum world, the ideas that the staff have institutionalized here have had a positive ripple effect. The Museum had been focusing inward, not outward into the community. Though we had good intentions—we were trying to protect our artistic mission—in fact we were eating away at our mission because we weren't connecting visitors with the works of art in our collections. The atmosphere was self-defeating.

So we went out into the community and in a series of forums listened intently to what Dallas-area residents thought of the DMA and what they wanted from us. While people in our community generally respected the Museum, some described a sense of detachment or the feeling that it was unwelcoming and even intimidating. We knew we needed to concentrate on creating a more accessible, meaningful experience for visitors.

As the Framework for Engaging with Art took shape, the Museum staff started to work across divisions and across disciplines. More people—including community partners—were

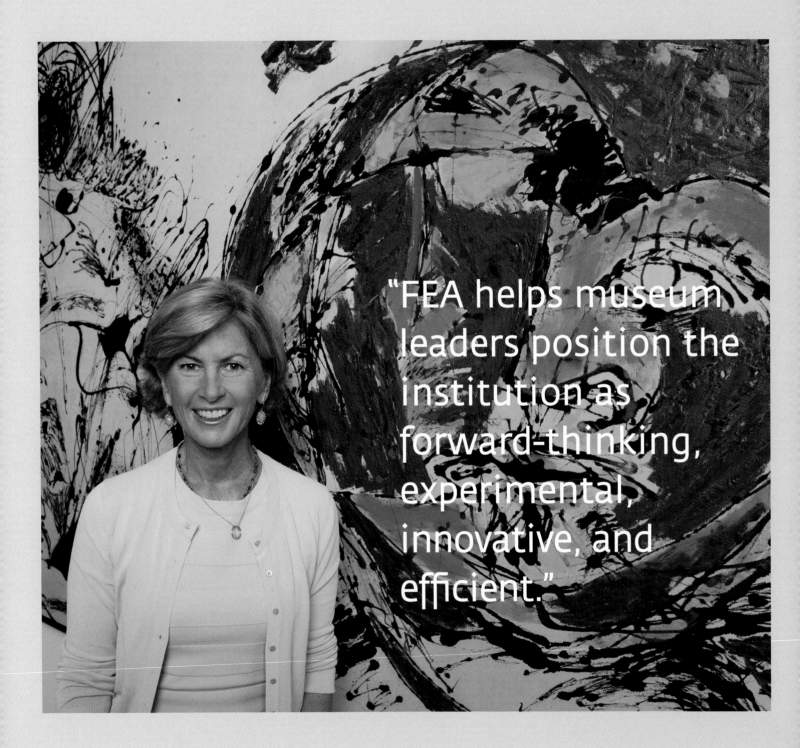

"FEA helps museum leaders position the institution as forward-thinking, experimental, innovative, and efficient."

invited to participate in decision making about collections, exhibitions, and programs. Flexibility and experimentation became the norm. Thanks to FEA and a Museum-wide dedication to change, we've seen a richer educational experience emerge, and there has been a dramatic increase in attendance.

The Framework for Engaging with Art has had an energizing effect on the Board. It's an extremely valuable learning tool for grooming well-versed, well-grounded trustees. Trustees come to any board with different knowledge bases. At the DMA, some new trustees have experience with cultural institutions, but some do not. As Board Chair I used examples from FEA when talking to the Board about the seismic shifts going on at the DMA and about our collective responsibility to make sure resources are in place so these shifts can continue. In many museums, board and staff leaders get so focused on fundraising that they don't take the time to show trustees how profoundly interesting a museum's work is. At every meeting, I used the research findings in some way to give trustees a context for our discussion.

I believe that FEA has great potential as a tool for donor education and cultivation. If you really want to engage thoughtful, smart people who will make institution-changing gifts, you have to let them know at a very deep level what you are trying to achieve. FEA helps Museum leaders position the institution as forward-thinking, experimental, innovative, and efficient. These are attributes that in the past one wouldn't have applied to the Dallas Museum of Art. Using FEA, we have been able to construct a set of metrics that are richer and more meaningful than details like how many people came to an exhibition. Internally, FEA is an excellent planning and budgeting tool because it helps us determine what works, discuss possibilities, and allocate resources.

Our strengthened visitor focus is squarely at the center of our current strategic planning process. The DMA could be the prototype for the 21st-century art museum. We're not going to have business as usual 25 years from now. The usual words, like *enliven* and *energize*, don't seem potent enough to describe what museums should be doing. They should be asking some probing questions: What is sacred? What needs to be protected? What needs to be enhanced? How do you build a platform that allows you to be totally nimble and engaged, both with the art and with the community?

Strategically, the DMA is poised to do something dramatic. The building blocks are in place: a collaborative model for working with other organizations, a leading role in the Dallas Arts District, deep and innovative relationships with collectors, experimental work across disciplines within the institution. There are many opportunities to take what we have done to the next level.

My wish for the DMA is that innovation, risk taking, and entrepreneurial spirit continue to be rewarded. The major advances over the past decade have raised public expectations. It's no longer enough to provide quiet viewing experiences, though those certainly are available. Many visitors are looking for the Museum to be multidimensional, with different ways of gaining access to art. The challenge for us—and for every art museum in the 21st century—is to respect those personal, transformational moments while creating active opportunities for people to be captivated by art.

THE FRAMEWORK

THE DALLAS MUSEUM OF ART'S FRAMEWORK FOR
ENGAGING WITH ART

INTEGRATING THEORY
AND PRACTICE

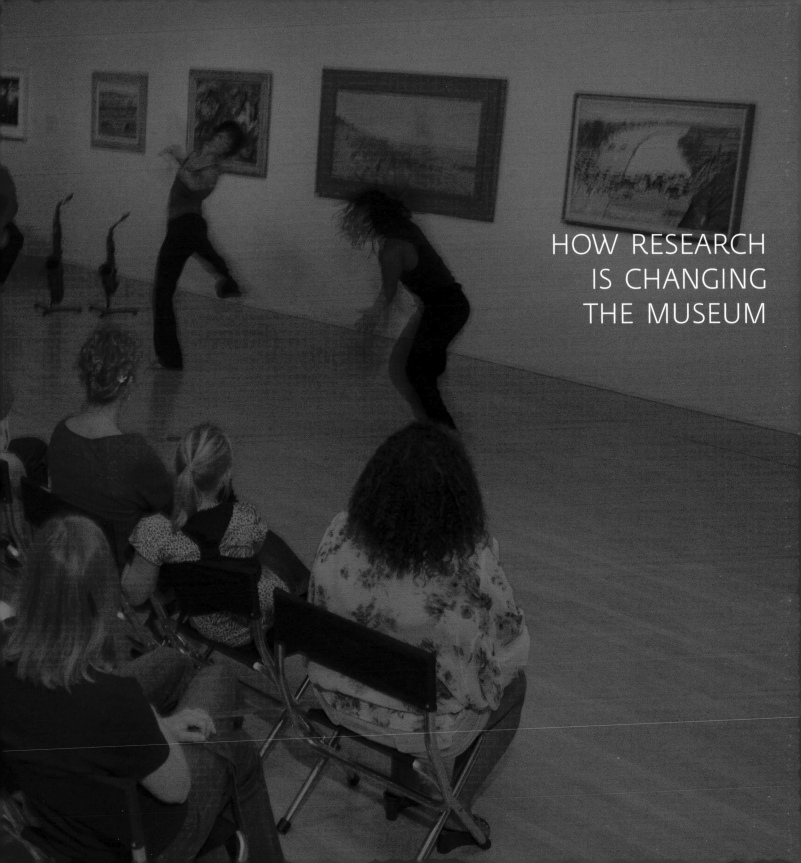

HOW RESEARCH
IS CHANGING
THE MUSEUM

Rigorous audience research at the Dallas Museum of Art yielded solid and compelling data that inspired us to think deeply about our visitors.

With the Framework for Engaging with Art as a tool for continued learning, we are blending a renewed understanding of visitors' distinctive qualities into the culture and values of the Museum. From the start, we wanted to move away from providing undifferentiated interactions with art and instead design experiences and provide opportunities that fit visitors' varied and distinct characteristics. But most important, we wanted to become a different kind of art museum.

Our vision for engaging our visitors centers on two values: creativity and collaboration. Today at the Dallas Museum of Art, the artist's creative process is as visible as the creative product. While works of art are celebrated in interpretation and programs, artists' voices are evident in multimedia materials and online content. Artists are intensely involved as creators, presenters, and participants (the Museum engaged more than 700 performing, visual, and literary artists in 2009).

We make it clear to visitors that the whole Museum is about creativity. Visitors are invited to explore their own creativity in the Center for Creative Connections, understand it as an innate human quality, and apply insights about creativity as they enjoy works of art in the collection. Each year, the DMA offers dynamic and richly diverse programs that actively engage the four clusters in experiences with art. The mix of programs is a critical characteristic of our efforts to reach new audiences and to achieve our goals. Over the years we have collaborated with a wide range of artists, scholars, and community partners to enhance our programming.

Collaboration at the DMA takes two forms: external and internal. Community partners—including arts and community organizations, universities, and elementary and secondary schools—help us diversify and multiply the experiences the Museum can offer. We could not have implemented ideas based on the Framework for Engaging with Art without these collaborative efforts, and they are essential to the Museum's continued success. Each partner contributes something different to the visitor experience, from the Booker T. Washington High School for the Performing and Visual Arts students who interpret a painting through dance to the nearly 600 North Texas residents who created personal collages that local artist Lesli Robertson wove together to create a community-based work of art.

Within the Museum, cross-divisional collaboration is a vital part of the way we work, from developing exhibitions to designing public programs and providing visitor services. With FEA as our guide, staff members are increasingly comfortable taking risks and seeking unconventional solutions. Naturally, we pursue success, but when formal evaluation or professional instinct show that we have not reached it, we regroup and try another approach. Experimentation is key to our work together, and we willingly accept the potential for failure.

This chapter illustrates the integration of creativity and collaboration into the Dallas Museum of Art with seven stories about processes and programs that exemplify the engaged art museum we have become.

A COLLABORATIVE WORKPLACE

In December 2008, 40 staff members—
several of them new to the Museum—
spent a day and a half immersed in
the FEA findings. Randi Korn & Associates had just
completed the second audience research report, which showed
that even when the context changed—different exhibitions,
different data collection times, different programming—the
four audience clusters (Observers, Participants, Independents,
and Enthusiasts) remained consistent. At the workshop, the
staff reviewed the intent of FEA: to build each audience cluster
and give visitors comfortable and meaningful experiences
that they choose on their own terms according to their
personal qualities and preferences. There were some revelatory
moments during the day as brainstorming revealed the
applicability of FEA to large- and small-scale ways staff could
work together and serve Museum visitors. This intensive
workshop was one of several held over seven years of FEA
research. Each time we met, we wrestled with the data,
questioned our interpretations, and deepened our collective
understanding. We operated as a community of learners.

The Framework for Engaging with Art has required a shift
in culture for 300 staff members in 26 departments, with
the successes and missteps that can be expected in a large
institution where attitudes and behaviors are being gently
and not-so-gently challenged. Staunch support from the
DMA Board and from staff leaders made rigorous research a
top priority. Today, our collaborative working style is evident
throughout the Museum, in attitudes and approaches as
well as in identity, programs, exhibitions, and partnerships
with artists and community organizations.

An expanded senior management team, including
curatorial affairs, collections and exhibitions, education,
development, finance and administration, marketing
and communications, and Board relations, better reflects
the core functions of the Museum's mission. Revamped
cross-functional teams involve multiple divisions in
decision making. A new Leadership Team composed of
26 departmental and divisional representatives actively
participates in planning and coordinating key institutional
projects and leading innovative thinking across divisions.

Signing on to FEA as a guiding concept was not simple for Museum staff, as institutional change inevitably requires personal change. Not all staff members have wholeheartedly embraced the idea of what they perceive as another layer of meetings and communication. There are very few underworked museum professionals—at the DMA or at any museum—and one more concept can feel intrusive when time is already scarce. But all staff, and now candidates for every professional-level position, know that visitor engagement is an institutional commitment that they are agreeing to pursue.

A working culture supported by the Framework for Engaging with Art has discernible benefits:

A common language—When we speak of addressing Observers, Participants, Independents, or Enthusiasts in program and exhibition development, we have a shared understanding of whom we are trying to reach and what we intend to achieve. Museum audiences—whether general visitors, teachers, or online users—are no longer an undifferentiated group.

Audience-focused—With a framework that lays out audience characteristics in detail, staff members have a steady reminder of the interests, needs, and capacities of visitors and potential visitors. Across departments and across programs and exhibitions, planning can encompass the different audiences effectively, and staff expectations can be focused and realistic.

Effective allocation of resources— When combined with program development, research about audience types is a useful budgetary tool. To maximize the impact of Museum resources, the staff can allocate work efforts and funds to serve and attract a diverse range of visitors in our community.

Targeted marketing—Museum staff identify long-term attendance trends or membership behaviors according to cluster and then design audience development or membership marketing to target and attract these audiences.

Integrated evaluation—Program evaluation and audience research are integrated learning and problem-solving tools that draw on FEA as a support and context for institutional effectiveness.

"I cannot say enough about the impact of taking on FEA as an institutional rather than a departmental initiative," says Gail Davitt. "As we bring on new staff we talk about what this means to us and how we are using it." Close collaboration and communication among staff in multiple divisions were rare before the shift in culture instigated by the research findings. Planning a year ahead in programming—with special attention to distribution across the four clusters—also marks a change in process. Jeffrey Grove, The Hoffman Family Senior Curator of Contemporary Art, says the FEA-driven approach was one reason he was attracted to the Museum in 2009. "Interpretation is integrated into the display of objects, and educators and curators work together to open up new understandings," he observes. "I believe the Framework for Engaging with Art has been instrumental in that process at the DMA."

COMMUNITY VOICE

A QUIET REVOLUTION

Dr. Harry Robinson Jr.

President and CEO, African American Museum

My relationship with the Dallas Museum of Art goes back more than three decades, as a Board member and as a friend and colleague of its Directors over the years. In the late 1990s, Jack Lane was concerned that the DMA was not connecting with its community, and recruited a leadership team to address these issues.

Within the DMA, people knew that change was necessary. It wasn't imposed from the outside. I'm a big proponent of listening to your community, and that's how they approached their challenges. As a member of the National Museum Services Board, I'm exposed to many different kinds of museums from all over the country. I can tell you that what's happening at the Dallas Museum of Art is remarkable. It's a quiet revolution.

Fifteen or twenty years ago, the Dallas African American community did not think very highly of the Museum and the other major cultural institutions. They felt they were not welcome. Based on my relationship with the Museum, I didn't believe that was true. But it was the perception, and perception is a big part of reality. Today, this attitude has shifted. People are

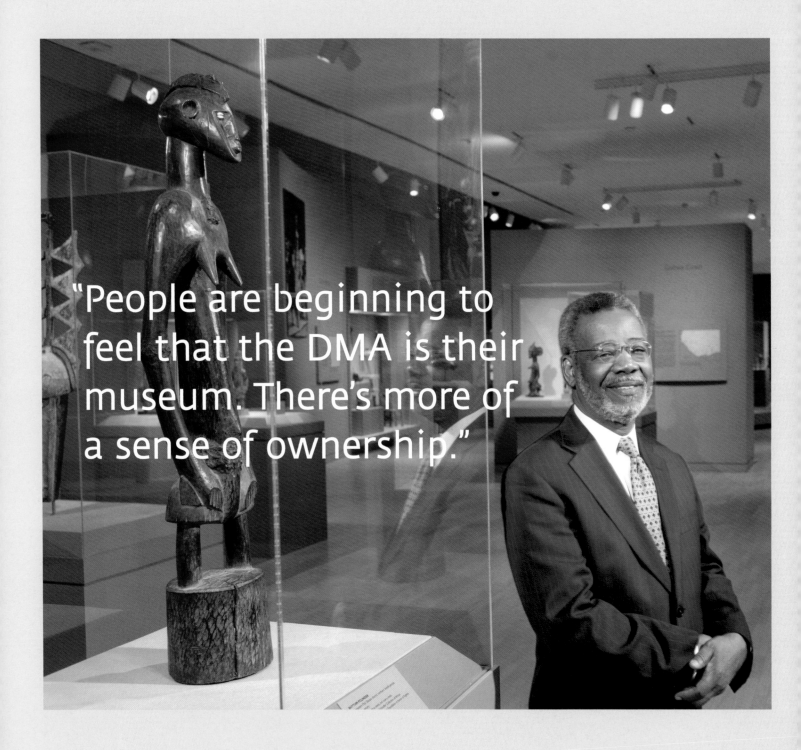

"People are beginning to feel that the DMA is their museum. There's more of a sense of ownership."

beginning to feel that the DMA is their museum. There's more of a sense of ownership. At one time, people looked upon the African American Museum as an alternative to the DMA, but that's no longer the case. They see the two museums as complementary.

Not every community engagement effort is as genuine as it could be. But that's not the case with the DMA. They're not just trying to keep the African American community happy, or bring in more visitors from the Hispanic community. They're making a real effort to bring in the *entire* community. That's why the DMA is successful. And you can see the difference as you look around the Museum.

In Big Thought's Thriving Minds program, they bring every fourth-grader in the Dallas Independent School District into the Museum for a tour led by a docent. With *The Art of Romare Bearden*, they made a positive statement by adding a piece by the artist to the collection. They held a free outdoor concert by Isaac Hayes as part of a Late Night celebration during the Gordon Parks exhibition, and 18,000 people came out on a summer night to enjoy the music. During evening hours the place is packed, and there's been a diversification of programming, so there's more to appeal to families. To celebrate the completion of the Dallas Arts District in September 2009, the DMA took the lead in a collaborative effort among the institutions in the district. The programming was of such high quality, and they did it in such a quiet, easy way, that all you saw were the results.

Over the years, the DMA has been a good partner with my institution. When we were struggling to raise money to open the African American Museum, the Museum's leaders were side by side

with us, even though they were in two major campaigns of their own at the time. They've always been there to give us technical support or consulting services. Today, we're the only museum in the southwestern United States devoted to African American art, culture, and history. We also have one of the largest African American folk art collections in the nation.

The impressive thing is that innovation, experimentation, and change have not broken the DMA's budget. They've just become part of how the Museum operates. I'm impressed with the competent and committed staff. You don't see dissension, with staff members pulling in different directions. It's truly a team approach. All this progress means that the Museum will have to work on some external challenges. The building is not easily accessible to public transportation, for example, so parking or shuttle service will be necessary as the DMA's popularity continues to grow.

I'm grateful for the opportunity to be a part of the Dallas Museum of Art and to reflect on the quiet revolution that's making such a difference in the way the Museum engages with its community. It's been an amazing transformation, and people are excited about what's still to come.

"The impressive thing is that innovation, experimentation, and change have not broken the DMA's budget. They've just become part of how the Museum operates."

A NEW ENVIRONMENT FOR EXHIBITIONS AND INTERPRETATION

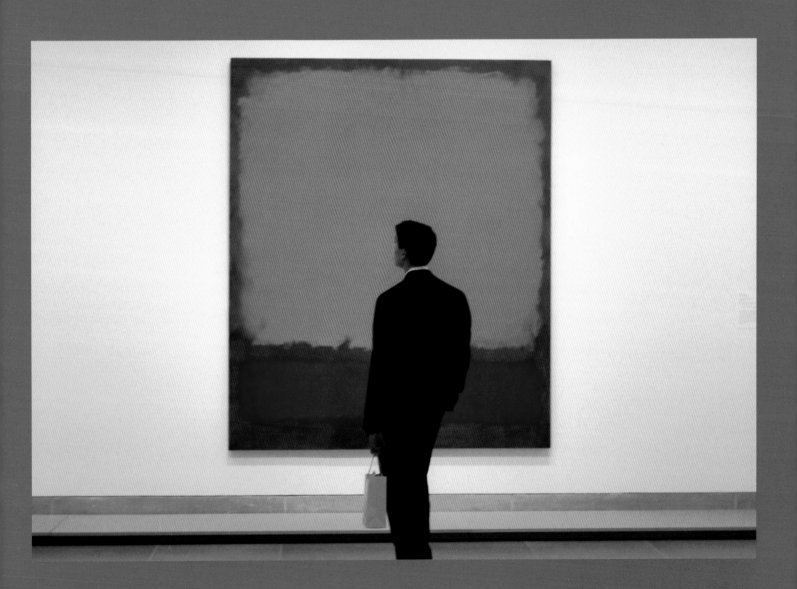

The Framework for Engaging with Art has driven a gradual shift in thinking about all aspects of gallery installation as Museum curators and their colleagues in Education devise novel uses of the DMA's collections. "In a way, FEA codifies the thought process that we apply to an exhibition's interpretive elements, including programming," explains Kevin W. Tucker, The Margot B. Perot Curator of Decorative Arts and Design. Five exhibition projects—all centered on the Museum's collection—illustrate the results of a commitment to FEA thinking:

Fast Forward: Contemporary Collections for the Dallas Museum of Art

In February 2005, as the Museum was working on the FEA audience studies, its future was transformed by an announcement of a benefaction to its modern and contemporary art collections that was unprecedented in scope and form. Dallas collectors Marguerite and Robert Hoffman, Cindy and Howard Rachofsky, and Deedie and Rusty Rose announced that they had jointly pledged their private collections, which included over 900 works of art, as an irrevocable bequest to the Dallas Museum of Art. Made early in the lives of these individuals, these generous bequests allow the DMA and collectors to work collaboratively to plan and build the Museum's collection for the future. Offering an important new model of community philanthropy within the museum world, this benefaction makes the Dallas Museum of Art one of the leading public collections of postwar and contemporary art in the nation.

To showcase this dramatic expansion, the DMA presented *Fast Forward: Contemporary Collections for the Dallas Museum of Art*. Organized by María de Corral, then the adjunct Hoffman Family Senior Curator of Contemporary Art, the multiphase exhibition filled the first level of the Museum from November 2006 to May 2007 and included more than 300 works of art.

To address the challenge of making contemporary art accessible and meaningful to audiences who may not

have a comfort level with its media, themes, and content, the exhibition team experimented with FEA-based visitor engagement strategies. Interpretive labels—at that time seldom a part of the Museum's contemporary art exhibitions—incorporated quotations from the artists about their works and their creative process. Along with the curator's voice on the audio tour, visitors heard interviews with collectors Marguerite Hoffman, Deedie Rose, Cindy and Howard Rachofsky, Gayle Stoffel, and Tim Hanley, who shared personal thoughts about the objects they had chosen to live with. Collectors' and artists' voices carried over into exhibition-related programming, which captured opportunities for all visitor clusters. Conversations and panel discussions, designed for Independents, included an event featuring the Museum Director in dialogue with three pioneers of Dallas collecting and a panel of local media artists reviewing the latest intersections of art and technology. For Observers and Participants, who appreciate having bridges to understanding art, we invited spoken-word artists to perform original poetry about the works of art for a high school symposium, then delivered rhythmic combinations of straightforward insights

Giuseppe Penone
Italian, born 1947

Skin of Leaves (Pelle di foglie), 1999-2000

Bronze
The Rachofsky Collection

I feel the forest breathing and hear the slow, inexorable growth of the wood.
—Giuseppe Penone

Giuseppe Penone often uses the tree as a metaphor for systems of growth and change. He has commented on his use of bronze: "Bronze is the ideal material for fossilizing plant life. In bronze, plant life preserves all of its appearance, and, if placed in the open, it reacts with the climate, oxidizing and thus taking on the same colors as the plants which surround it."

Label for Giuseppe Penone's *Skin of Leaves* (opposite) from the exhibition *Fast Forward: Contemporary Collections for the Dallas Museum of Art*

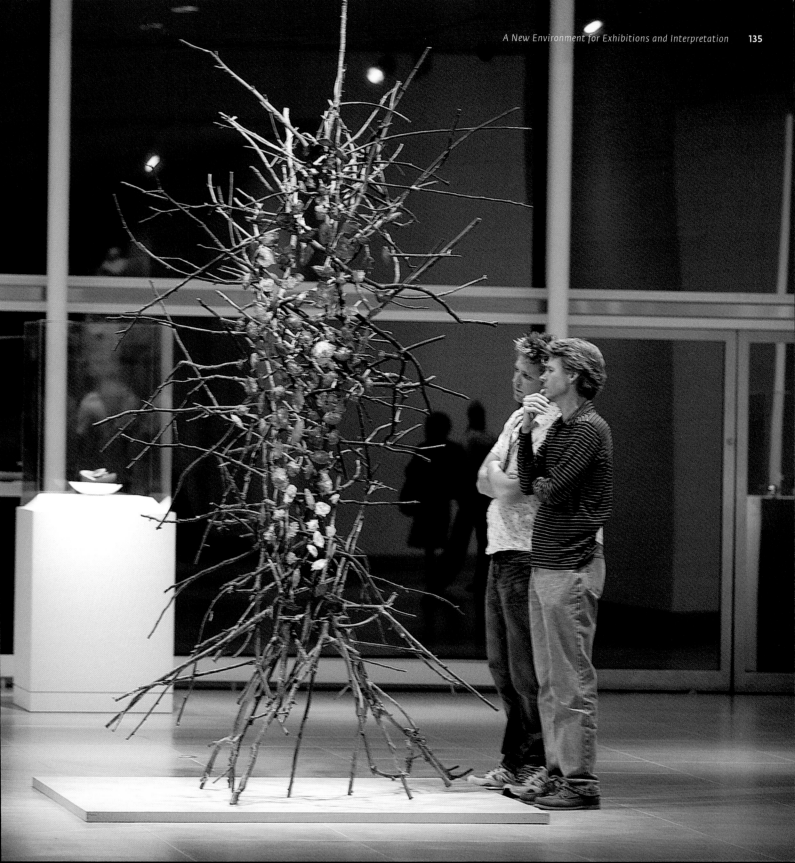

and poetic responses at Late Nights. The Arts & Letters Live series targeted Participants and Enthusiasts with a multidisciplinary extravaganza of song and poetry created to resonate with works of art in the exhibition.

Fast Forward offered the Museum an opportunity to rethink the interpretation of contemporary art and to introduce new perspectives for visitors. It was a critical step in raising the prominence of contemporary art and planning for interpretation and visitor engagement in the future.

Summer Spotlight

The intent of the 2009 FEA-based collections project *Summer Spotlight* was for visitors to look at art through a cinematic lens and find connections between going to an art museum and going to the movies. The experiment was conceived with Observers, Participants, Enthusiasts, and Independents in mind. Interpretive materials blended the voices of artists and community partners—especially high school and college students—with curatorial voices. *Summer Spotlight* featured 30 works of art shown throughout

the galleries instead of in a dedicated exhibition space. Visitors chose their own paths to explore the spotlighted works. They could take a self-guided tour of all 30, focus on a few, or rely on serendipity to discover them while on a general tour of the galleries. A pedestal in front of each work of art held a special label telling a story that connected the work to a movie genre: action and adventure (*Orpheus Taming Wild Animals*, a Roman mosaic from A.D. 204), love and romance (John Singleton Copley's pair of portraits from 1767, *Woodbury Langdon* and *Sarah Sherburne Langdon*), horror and mystery (a head of the rain god Tlaloc from the ancient American Mixtec culture of Mexico), and drama (Frederic Edwin Church's *The Icebergs* of 1861). Each object was accompanied by questions phrased to evoke linkages to movies and by a short list of related films.

For Jackson Pollock's abstract expressionist "drip painting" *Cathedral* (1947) and his later *Portrait and a Dream* (1953) exhibited nearby, the label text read:

Action! Imagine the artist standing over a long length of canvas. He lets paint flow from the end of a brush or stick as he moves around the canvas, carefully layering drips and splatters. He stops to consider his next move before adding the next layer of paint.

In *Cathedral*, Jackson Pollock's carefully choreographed dance with paint and canvas results in a completely abstract web of lines that intersect, swoop, break, and overlap. This is one of the first paintings in which Pollock perfected this drip technique, referred to as "action painting."

In the later painting *Portrait and a Dream*, featured in the movie *Pollock*, the artist returns to the figure, incorporating his personal portrait, covered by a mask. On the left, a reclining figure might reflect the "dream" of the painting's title.

Movie Connection: Have you seen movies about artists? Ed Harris played Jackson Pollock in the movie *Pollock*. Is that who you would have cast?

Check Out: *Pollock, Vincent and Theo, Girl with a Pearl Earring*

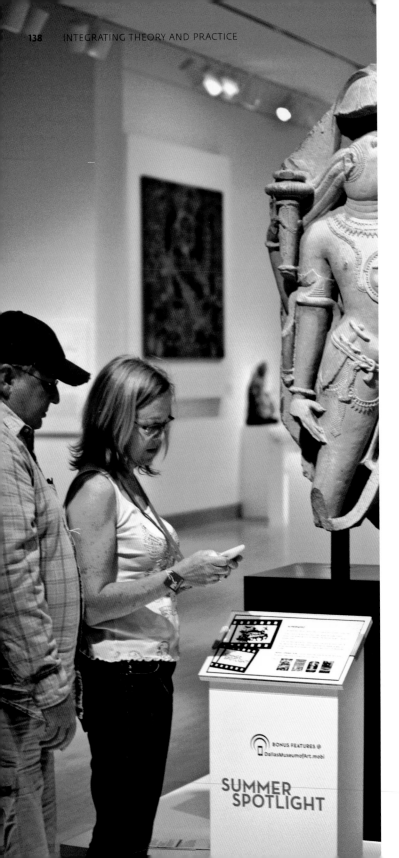

With *Summer Spotlight* we experimented with Web browsing–enabled mobile technology as an online and onsite interpretive tool. Visitors could check out an iPod Touch or use their own smartphones. Multimedia Bonus Features (named to reflect the movies theme) were designed for various clusters and included videos, audio clips, and sound interpretations produced by faculty and students from the Arts and Technology program at the University of Texas at Dallas. Most of the content came from the Museum's growing digital content repository, part of the Arts Network (see pages 200-07).

Bonus Features at the Pollock stop included an excerpt from Hans Namuth's 1950 film of the artist talking and painting, several short clips of a Museum curator discussing Pollock's early life and his work as a response to postwar America, a sound interpretation of *Cathedral*, and a video response by students from the Booker T. Washington High School for the Performing and Visual Arts. We expected that Participants would enjoy the sound and video responses and that Independents would gravitate toward primary sources, such as the Namuth film.

Summative evaluation of *Summer Spotlight* yielded information for improvement and further experimentation. We learned that visitors need more explicit guidance when encountering new interpretive formats or materials. Though the pedestal labels were large, with dramatic lighting and graphics, they were less successful than expected. Some visitors did not even notice them. Many said they were not aware of the Bonus Features, and we experienced some functionality issues that complicated visitor use. Based on what we learned, we refined the mobile tour prototype and added a short, step-by-step tutorial available at http://www.DallasMuseumofArt.mobi. We also trained visitor services staff and gallery attendants to help visitors use the mobile devices and access the mobile tours. The latest generation of interactive multimedia tours—called smARTphone tours—made their debut in February 2010 in the Wendy and Emery Reves Collection and in the exhibition *Lens of Impressionism*, and have been markedly more successful.

Targeted program initiatives developed for *Summer Spotlight* yielded positive results. Extending the typical Sketching in the Galleries format to involve anime artists and costume designers was intended to attract Observers to a program that may usually appeal to Participants and Enthusiasts. In the C3 Tech Lab, we hoped Enthusiasts and Independents would enjoy documentary filmmaking while Participants would create their own three-minute interpretations of art in the collections. As part of a Family Celebration, professional actors stepped into character, encouraging parents and children to create costumes and props and then act out stories from works of art. Late Nights featured programs like film-focused collection tours, movie music performances, and Soundtrack Karaoke, which was so popular that karaoke is now a regular Late Night item. *Summer Spotlight* also deepened the Museum's relationship with the Dallas Film Society, which has led to an ongoing collaboration. *Summer Spotlight* turned out to be a marketing success, because it showed that promoting a collection concept instead of a traditional exhibition could draw visitors to the Museum.

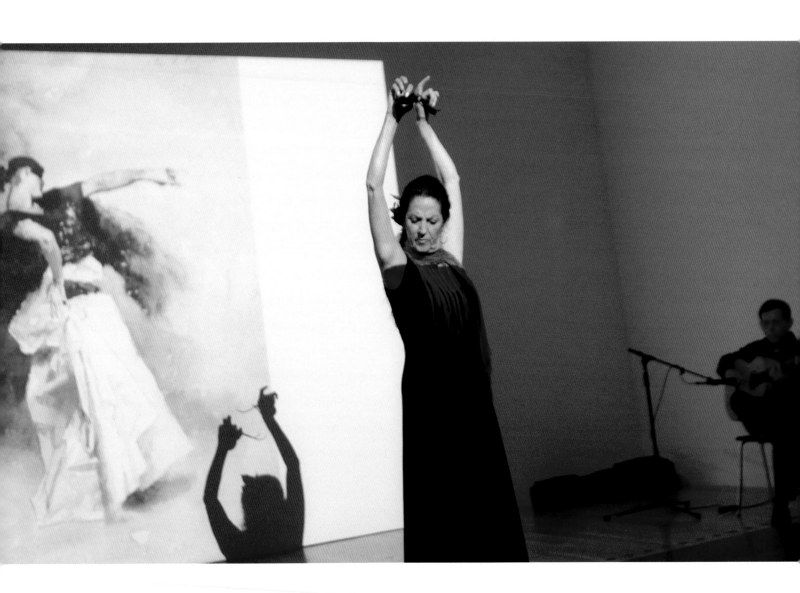

All the World's a Stage: Celebrating Performance in the Visual Arts

In August 2009, the exhibition *All the World's a Stage: Celebrating Performance in the Visual Arts*—which honored the opening of the AT&T Performing Arts Center and the completion of the Dallas Arts District—introduced a thematic exhibition concept and installation that integrated theory and practice and fulfilled much of the intent behind FEA.

Many ingredients merged in this innovative presentation: the rich variety of the Museum's collection, the active involvement of artists, a high level of community partnership, and the creativity of the staff. *All the World's a Stage* was a shared effort by all the Museum's curators—unusual in conventional art museum practice. Working in collaboration with the education and exhibition staff, they creatively mined the collection, identifying over 125 paintings, sculpture, photographs, and other objects from every area to illustrate the exhibition themes. "No other museum in the area could offer such a diverse overview, or put an 11th-century Chola bronze of a dancing Shiva with Degas' ballerinas and a Nigerian Egungun costume," reviewer Gaile Robinson wrote in the Fort Worth *Star-Telegram*. "The result of putting an Art Deco radio with a Greek mosaic of Orpheus and watercolors of a twirling Isadora Duncan is one of the most powerful statements [the curators] have collectively ever made."

Strong interpretive components joined with these carefully chosen works of art to create an immersive environment. Visitors could step up to the Music Bar and listen to a selection that related to a favorite work of art. Watching video on small monitors placed near specific works, they could understand the performance context of an African masquerade or a Guatemalan textile. Or they could read some of the 20 community response labels, by people such as directors and actors, that accompanied curatorial labels.

Other perspectives of artists, actors, musicians, priests, and dancers filled the galleries with the energy and spirit of performance in the community. In The Stage, a central area that served as a town square for the arts, local artists

Trumpet

Peru: south coast, Paracas culture, c. 300–200 B.C.
Ceramic and resin-suspended paint

Anonymous gift in honor of John Lunsford, 1986.23

Paracas musical instruments are rare, yet music was almost certainly a part of special events in this early South American culture. The undocumented sounds of ceramic trumpets such as this one probably accompanied those celebrations. The remarkable length of this example must have required either an extra person or a brace to support it when it was played.

The humanlike form that decorates the bell of the trumpet represents a mythical or religious figure called the Oculate Being (after the prominent concentric circles of the eyes). The unusually large head may represent a mask of the supernatural. Whether a depiction of an Oculate Being or of a human being costumed as one, the presence of a supernatural image on the trumpet elevates the function of the instrument to a ritual realm.

Response to Trumpet

Historically, mankind has relied on the trumpet for military and religious purposes. In the DMA's recent Tutankhamun exhibition, there were trumpets dating back to 1500 B.C. In medieval times, trumpet playing was a guarded craft; trumpeters were often among the most heavily guarded members of a troop, as they were relied upon to relay instructions to the army. Today the modern bugle continues this signaling tradition. (Boy Scouts can earn a merit badge by mastering bugle calls: "First Call," "Reveille," "Assembly," "Taps.")

In the spring of 1972, I was asked to fill in for a VFW bugler who was ill. I vividly remember standing a good distance from the interment ceremony and playing "Taps." As I played everyone started to sob; the emotions from that gathering haunt me to this day as I dutifully carry out my mission of "Trumpeter."

Luis E. Martinez
Dallas Wind Symphony
Coordinator, Music Cluster
Booker T. Washington High School for the Performing and Visual Arts

Curatorial and community response labels for the Paracas trumpet from the exhibition *All the World's a Stage: Celebrating Performance in the Visual Arts*

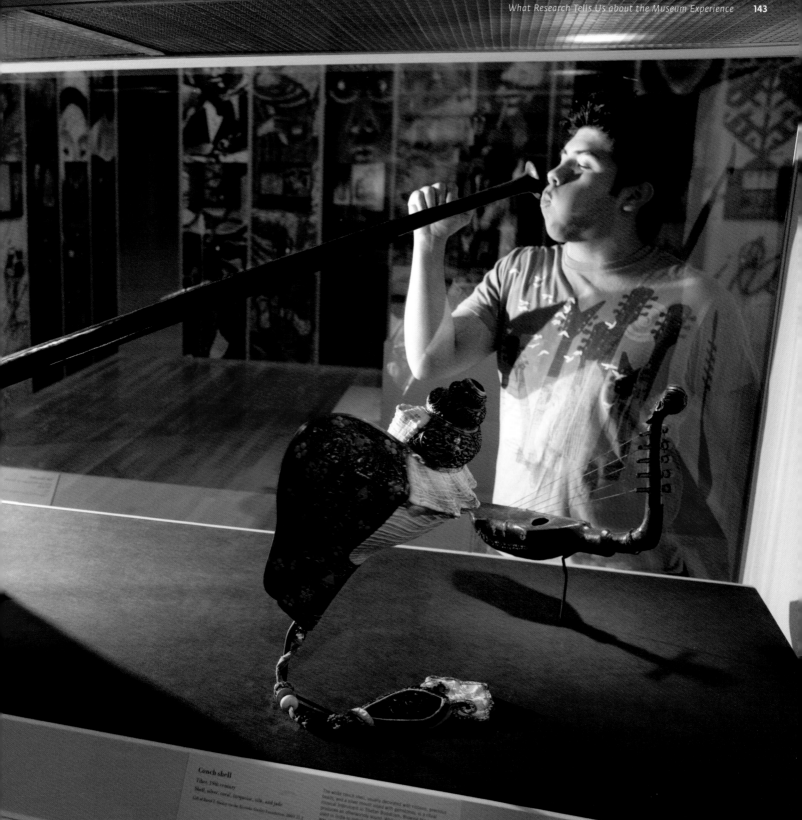

Conch shell

Tibet, 19th century

Shell, silver, coral, turquoise, silk, and jade

Gift of David T. Owsley to the Alturas Owsley Foundation, 2007.11.2

The white conch shell, usually decorated with ribbons, precious metals, and a silver mount inlaid with gemstones, is a ritual musical instrument in Tibetan Buddhism. Blowing the conch shell produces an otherworldly sound. While similar conch shells were used in India to sound battle, like a war trumpet, a high-level religious or the

presented more than 200 performances. Learning from visitors' interest in similar spaces in two earlier exhibitions, we created The Stage as a much larger, more versatile area with increased seating and a greater variety of programs, including theater, music, dance, film, and informal discussions. When programs were not being presented, visitors could watch a looped video of interviews with performing artists in conjunction with a slideshow of related works in the collection. The interviewees included Thomas Riccio, a multimedia artist and professor of performance and aesthetic studies at the University of Texas at Dallas, who described performance as a vital point of reference for a culture, and choreographer Michelle Hanlon and dancer Jennifer Manus, who expressed the joys and challenges of their piece *The Guitarist/Outside-In*, created in response to Pablo Picasso's *The Guitarist* of 1943.

Performances also complemented public lectures. After Larry Coben's presentation on the Incas' use of ritualized performance, spectacles, and theatricality, an Inca folk group performed music from Peru. We hoped this experimental format would entice Independents to attend a performance—not their natural preference—and encourage Participants, who do appreciate performances in the galleries, to attend both the performance and the lecture. Feedback from visitors and art critics, as well as healthy attendance, indicated that the experiment was a success.

Throughout the Museum, the themes of *All the World's a Stage* translated into film screenings, conversations with artists, performances, poetry readings, discussions about the state of the Dallas arts community, Late Nights and family programs, and complementary programs in the Center for Creative Connections. The staff thought about every visitor cluster. They wanted Independents to appreciate the artist's voice, Participants and Enthusiasts to enjoy interactive experiences, and Observers to respond to daily films, jazz concerts, and changing Late Nights program menus.

The tight schedule and conservative budget for *All the World's a Stage* were a sign of the economic times. But these conditions turned out to be advantages, not limitations. The exhibition celebrated the vitality of the community's artistic

resources, the assets available in the DMA's encyclopedic collection, and the drive to test the possibilities presented by the Framework for Engaging with Art.

An Evolving Environment

The DMA's environment for engaging with art through exhibitions and interpretation continues to take shape. The 2010 exhibition *Coastlines: Images of Land and Sea* featured thematic arrangements of paintings, photographs, and works on paper, novel interpretive concepts, and programs created for every visitor cluster. Through some 60 selections from the Museum's collection (with a few from local collectors), the exhibition considered coastal landscapes as a source of inspiration, metaphor, and mystery for visual artists from 1850 to the present. Unexpected combinations of artists, media, and artistic traditions in five thematic groupings "offered visitors an array of artistic lenses," says Heather MacDonald, The Lillian and James H. Clark Associate Curator of European Art. Each work of art was accompanied by a label consisting of a literary quote that evoked the coastal theme, rather than a traditional curatorial label.

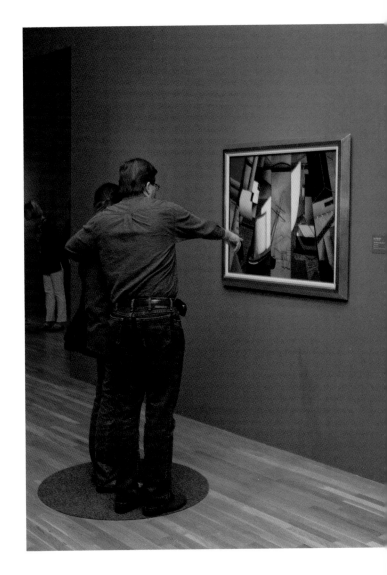

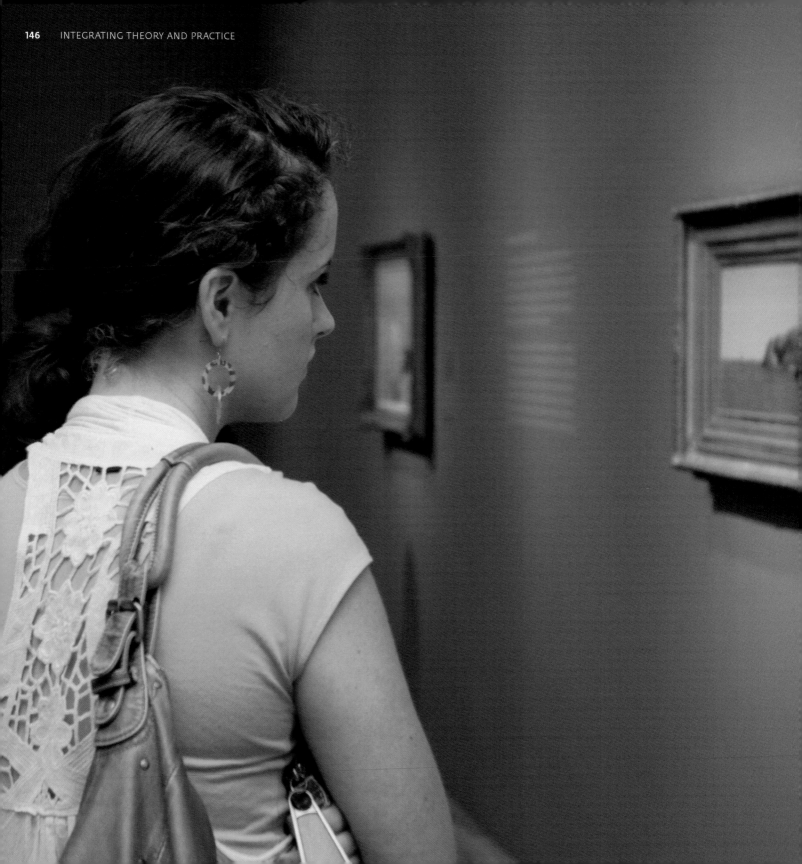

In their most ambitious collaboration with the Museum so far, faculty and graduate students in the Arts and Technology program at the University of Texas at Dallas built on their *Summer Spotlight* experiments to compose an interpretive soundscape for the exhibition space. MacDonald calls the sound installation an "immersive corporeal experience." "It's certainly a risk that some people might find the sound intrusive," she says, "but there's a freedom to experiment at the DMA. I think this is an experiment worth trying."

Again, Museum staff planned exhibition-related programs for Observers, Participants, Independents, and Enthusiasts, as well as for combinations of clusters. Film screenings during *Coastlines* featured movies set on the beach or at sea and were followed by commentary from critics, filmmakers, and curators about the inspiration of coastal landscapes. A concert by surf guitar legend Dick Dale headlined a Late Nights Summer Block Party. Lectures, concerts, tours, and family activities all used the coastal theme.

John Frederick Kensett
American, 1816-1872

Newport, Rhode Island (Beacon Rock)

1872
Oil on canvas
Gift of Mrs. Eugene McDermott, 1994.6

"When beholding the tranquil beauty and brilliancy of the ocean's skin, one forgets the tiger heart that pants beneath it; and would not willingly remember that this velvet paw but conceals a remorseless fang."

 Herman Melville (American novelist, 1819-1891),
 Moby Dick, 1851

The label accompanying John Frederick Kensett's *Newport, Rhode Island (Beacon Rock)* (above) from the exhibition *Coastlines: Images of Land and Sea*

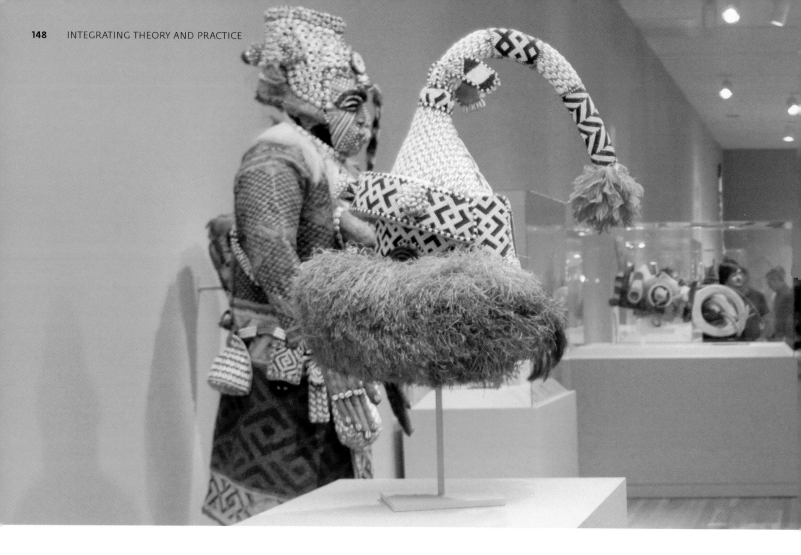

Drawing on the Museum's extensive resources—this time, the growing collection of African masks and recent scholarship published in the DMA's collection catalogue *The Arts of Africa*—the fall 2010 exhibition *African Masks: The Art of Disguise* explores the dual purpose of a mask: to conceal the identity of the wearer and to reveal the identity of the spirit the mask personifies. Some masks are presented as sculpture, and some are shown in a complete masquerade as they were intended to be seen. Creative partnerships with the Dallas Zoo and Dallas Black Dance Theatre enhance the exhibition with programs and performances. *African Masks* has a strong multimedia component, inspired by the positive impact of similar content in *All the World's a Stage*. An extensive smARTphone tour highlighting 19 of the masks accompanies the exhibition.

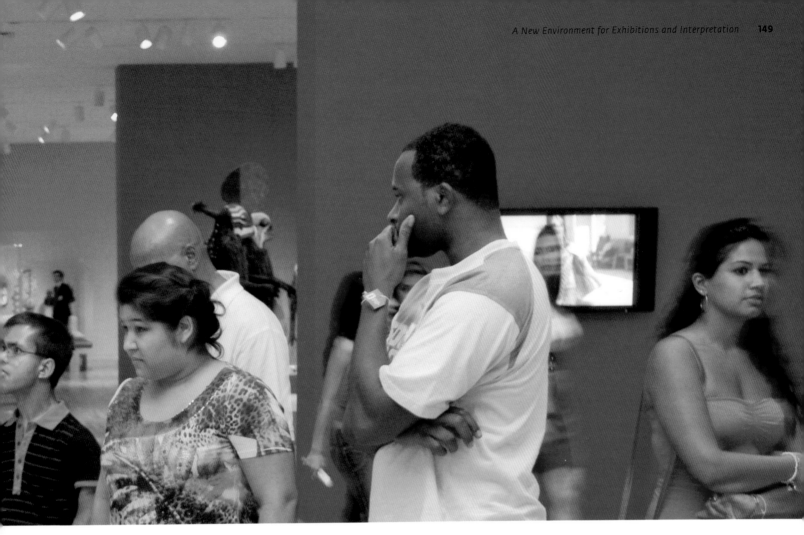

There is more to come. Roslyn Walker, Chair of Curatorial Affairs and The Margaret McDermott Curator of African Art, believes that this exhibition "provides deeper and more extensive learning that we can apply to the upcoming reinstallation of our African collection." That approach applies across the Museum's collections. Experiments with exhibition themes, content, and interpretive format at the DMA build on one another, as evaluation and reflective practice show what works for different audience clusters, what has promise but needs refinement, and what is not effective. Conversations about digital content, public programs, teacher programs, and community partnerships take place simultaneously. With the focus solidly on the art, the aim is a multifaceted visitor experience that stimulates curiosity, reflection, and deeper looking.

CENTER FOR CREATIVE CONNECTIONS

Center for Creative Connections

DALLAS MUSEUM OF ART

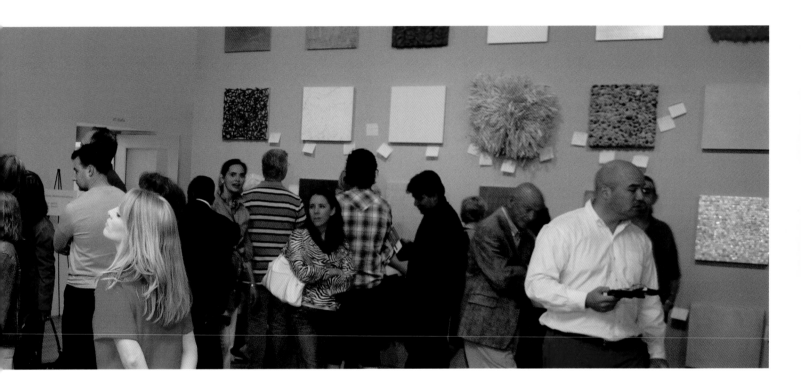

As a concept and as a space, the Center for Creative Connections embodies the Dallas Museum of Art's response to what research has shown about visitors' engagement with art.

This innovative learning environment, which opened on the first floor of the Museum in 2008, introduces multiple options for visitors of all ages, in every audience cluster, to observe and experience the creative impulse. C3, as it is called within the Museum, is a studio, laboratory, exhibition space, theater, classroom, and gathering place

rolled into one. It invites exploration of creativity from two perspectives: that of the artist and that of the participant. Visitors learn about the artist's creative process as they view and learn about real works of art and interact with artists. They test and refine their own creativity by exercising curiosity, reflecting on the artistic process, and making art.

At the entrance, visitors read this "user's guide":

Center: Experience a place that opens up possibilities for seeing art in new ways

Creative: Explore the creative process by interacting with art and artists, and creating your own responses

Connections: Connect with artists, works of art, and the community through close looking, new technologies, and exciting programs

The whole experience is self-directed, with visitors moving through the 12,000-square-foot space on their own or with companions or family members. They explore the works of art from the collection that are on view in the current interactive exhibition, taking 360-degree turns around some objects and sitting quietly next to others. They pause to write, touch, read, and create. Personal responses flow freely, as thoughts scribbled on Post-it Notes or as phrases, poems, and lists formed from magnetic words. People talk with a visiting artist about an imaginative community response work of art, or choose among a variety of free, multigenerational programs, from family workshops to adult classes. Staff members are always on hand for guidance and conversation. Visitor numbers have exceeded expectations: Almost one in every three visitors who come to the Museum uses the Center.

Unlike some interactive museum environments, C3 is not a separate space with its own program offerings, but a hub for experiences that involve gallery-based components designed for teachers, students, and the general public—all ages, many goals and interests, and every audience cluster. Consider this program sampling from a typical week: A group of teenagers spent Saturday afternoon with visiting artist John Grandits, exploring the collection and then creating their own art-inspired concrete poems in the Tech Lab. Young families enjoyed a toddler-paced art program

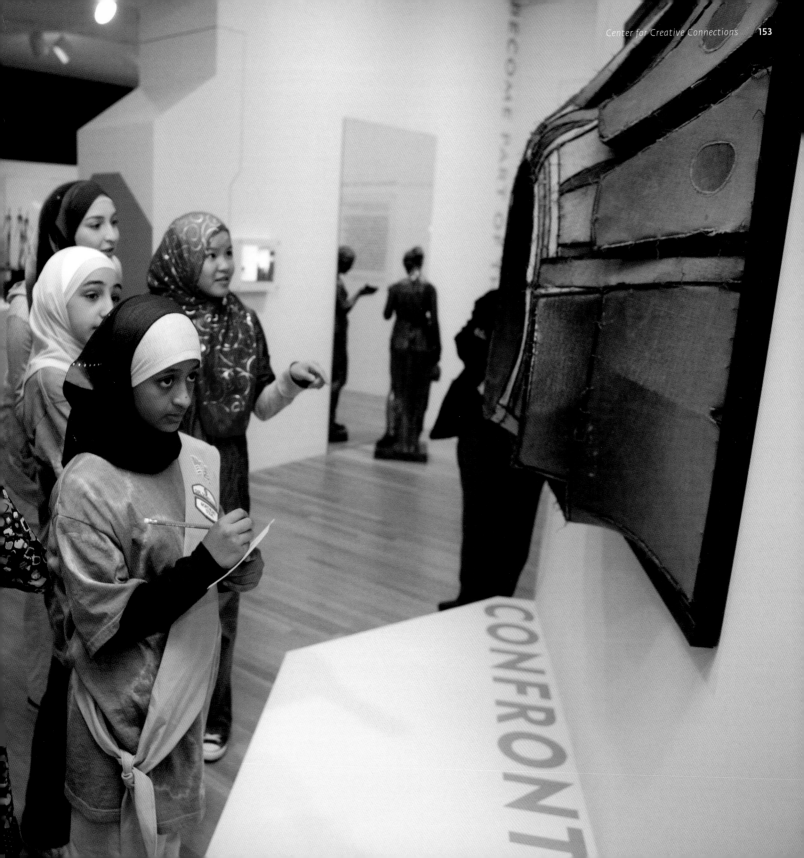

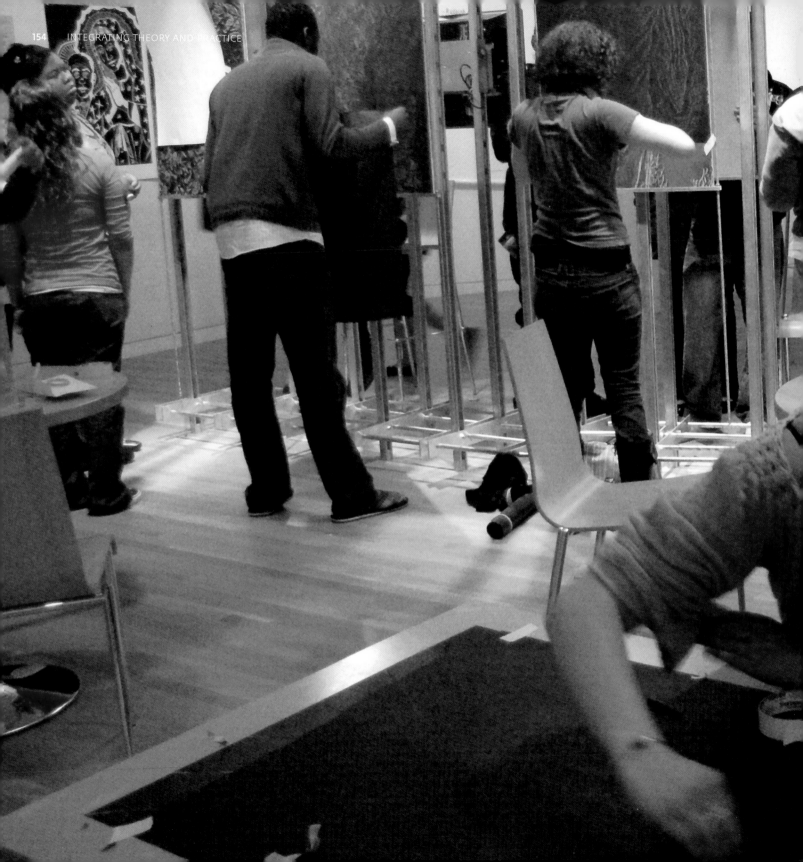

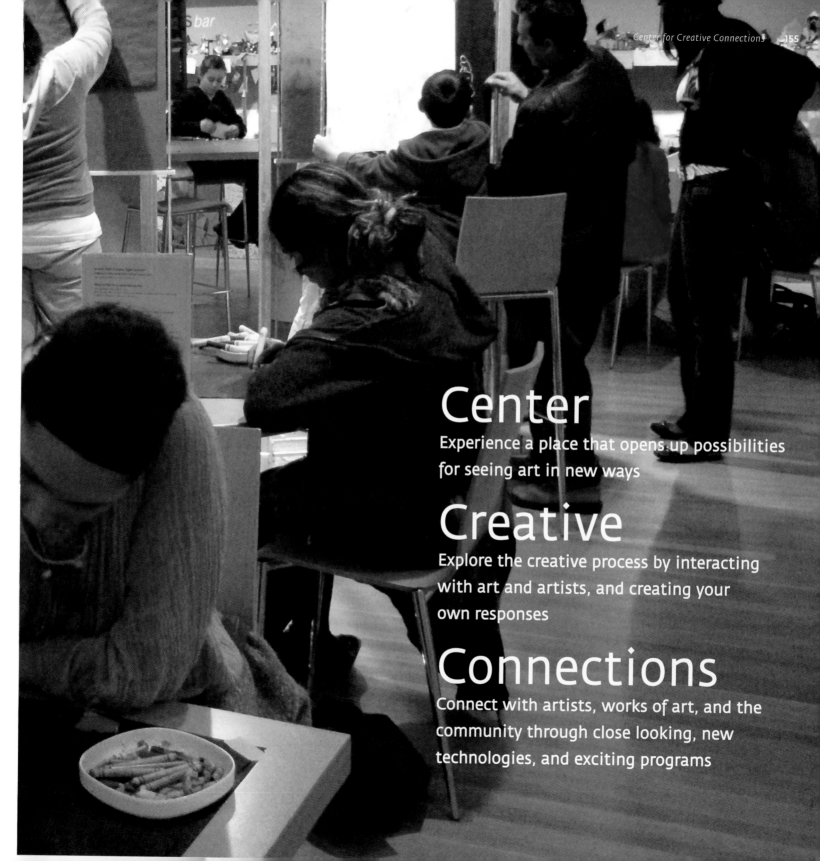

Center

Experience a place that opens up possibilities for seeing art in new ways

Creative

Explore the creative process by interacting with art and artists, and creating your own responses

Connections

Connect with artists, works of art, and the community through close looking, new technologies, and exciting programs

The exhibition *Encountering Space*, which opened in fall 2010, invites visitors to think about their physical and emotional reactions to space in works of art and how those reactions affect their experience. How does an artist give you a vantage point within a painting? Where are you? How can you actually become a part of the space of a work of art? How does the story of a sculpture unfold as you walk around it? How can culture influence how space is depicted and perceived in a work of art?

Using 11 works of art from the Museum's collection, *Encountering Space* was created by cross-divisional teams that represented the DMA's collaborative working culture. A large team including education, curatorial, and exhibitions staff chose the theme of physical space after extensive dialogue about how to reach and involve multiple audiences. A smaller content team strengthened and refined the exhibition development process by inviting closer communication with Museum staff.

Encountering Space also involved deepening external collaboration. The staff initiated conversations with

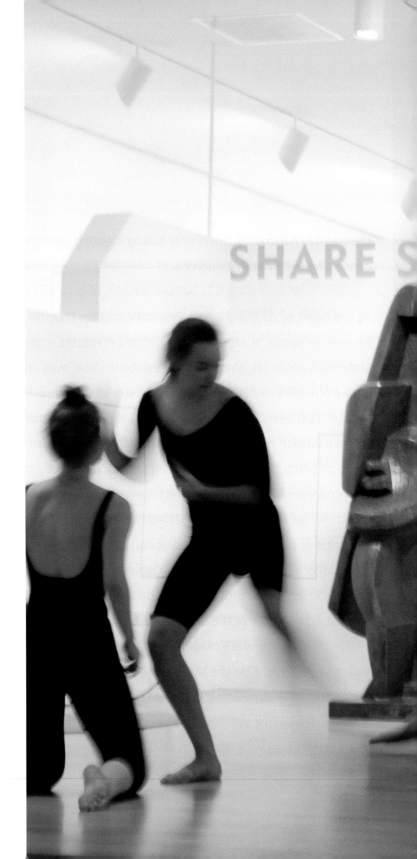

colleagues in science and children's museums, who shared their knowledge of building interactive spaces with integrated programming. Alumni and faculty from the Meadows School of the Arts at Southern Methodist University partnered with Museum staff on an immersive environment that responds to the space-related concepts of the exhibition. *Encountering Space* also includes several areas for visitor participation.

Since it opened, the Center has hosted 370 artists, from painters, storytellers, and poets to filmmakers, sound designers, and photographers. Some are visiting artists who collaborate with staff to develop and implement Thursday evening interactive programs for adults, and some work with docents and school programs. Others bring together community members and visitors to create response components in the space. "Artists are a part of what we do," Susan Diachisin, The Kelli and Allen Questrom Director of the Center for Creative Connections, explains. "They are our best guides for exploring the creative process and supporting that process in our visitors." Fiber artist Lesli Robertson (see pages 164–67) was one of several artists to respond to *Materials & Meanings*. Her textile-based installation *Woven Records* was a collaboration with 581 people from 16 community groups, along with Museum visitors, who made small collages that Robertson incorporated into the larger work. The choices that the community artists made, Robertson observed, revealed the meaning of materials as a form of artistic expression.

Community collaborations arising in C3 are often significant, long-term relationships based on shared aims, and many result in community response installations. Architecture and interior design students from the University of Texas at Arlington, for example, devised an innovative construction that drew attention to the ways they work with materials in their individual disciplines. Visitors could touch hard, curving walls that looked soft and run their fingers over curtains made of household materials like rubber bands and binder clips. Thirty-three students from a printmaking class at the Booker T. Washington High School for the Performing and Visual Arts spent two semesters working on large-scale multi-plate prints in response to Janine Antoni's *Lick and Lather* in the

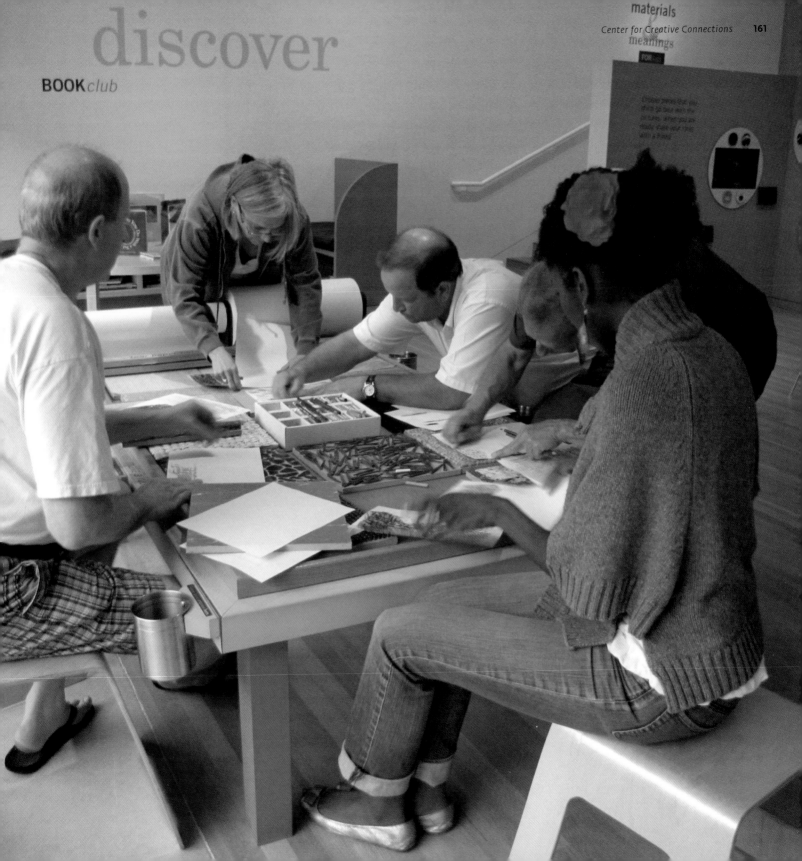

discover

BOOKclub

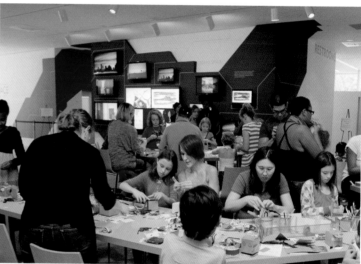

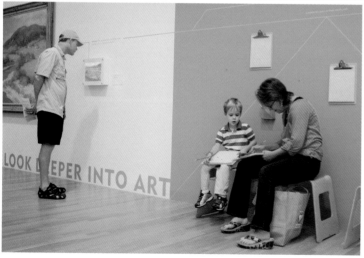

Materials & Meanings exhibition. The printing plates made from industrial, nontraditional materials were incorporated into tables as part of the installation. In another community response exhibition, 11 students from the University of North Texas explored new media and visitors as materials in their interactive installation. These engaging works kept visitors laughing and playing as they became aware of themselves as part of a work of art.

Evaluation studies of the Center for Creative Connections reveal that it provides both a social and a personal experience that inspires creativity and self-confidence in visitors and affects how they relate to works of art. One young boy was so enthusiastic about the cardboard replica of a Frank Gehry chair in *Materials & Meanings* that he made his own version at the Materials Bar and then continued making chairs out of different materials at home. A man who hadn't practiced his own art for years left C3 determined to begin again. A square of silver on the Materials Wall stimulated Post-it "conversations" among visitors about personal associations it evoked: "The silver reminds me of the turkey on the silver platter at Thanksgiving." Touching

a stone "is like walking barefoot on my grandmother's patio in the summer." Interviews reveal that visitors appreciate the chance to have their voices heard and sense the Museum's validation of their ideas. Less effective is the Learning Links area with computer terminals and other resources, which promotes a more traditional investigation of themes and artworks. Evaluation and observation have shown that visitors are not drawn to this area as much as to other features that promote active looking, learning, and creative response.

The Center for Creative Connections generates a sense of community response and ownership of creativity, and communicates that the whole Museum is about creative connections. As visitors move from C3 into the galleries to connect with works of art, on their own or with artist- or staff-led programs, they take this ownership with them for a deeper and more rewarding experience.

More information on C3 and its current exhibition, *Encountering Space*, can be found at http://DallasMuseumofArt.org/CenterforCreativeConnections.

COMMUNITY VOICE

ARTIST, MUSEUM, AND COMMUNITY

Lesli Robertson

Artist, Curator, and Lecturer at the University of North Texas

As an artist, I have a need to create objects—an internal, solitary process in my studio. When I traveled to Uganda to continue my research on Ugandan bark cloth, I came away with another, slightly different perspective that has deeply influenced my body of work over the past few years. I began to wonder how I could share my appreciation for beautiful materials and techniques with others and in that way stimulate more awareness of different art forms.

My first experience in working with a community to make a work of art was a collaboration with the Ugandan artist Fred Mutebi. Susan Diachisin, The Kelli and Allen Questrom Director of the Center for Creative Connections, knew about that project, and she asked me to think about how I could do the same thing here in Dallas, based on my own perspective as an artist. It was an incredible opportunity that represents the Dallas Museum of Art's commitment to connecting artists with people as a way of enriching the experience with art.

I had the privilege of working with Museum visitors, volunteers, and members of 16 community partner organizations in North Texas. There were more than 580 participants, and each one

"The Museum opened a new way of working that, for me, is such a natural and exciting process."

made a small, personal collage using different media. Then each person recorded a written response to his or her artwork. The collages were set in concrete forms about one and a half inches square, and I incorporated them into a larger woven piece installed on a six-foot-high wall in the Center. Susan and I wanted the community involvement to continue, so I used the written text to create a video that was projected onto two large vertical looms installed in the Center. As visitors wove on these looms, they created the screen for the video.

Woven Records is the first community response art project that the Museum has done in conjunction with a single artist's work. It was on view from February through July 2010. We

started by sending the word out that I was formulating an idea for a community work of art. We asked Museum staff who worked with community groups for ideas, and we looked at all of the DMA's outreach programs. We ended up with a diverse group, including ARC of Dallas, Tulisoma Learning Partnership Festival, an Ice House camp facilitated by the Museum, the Cathedral Shrine of the Virgin of Guadalupe in the Dallas Arts District, and faculty from Booker T. Washington High School for the Performing and Visual Arts. We also involved many Museum visitors and volunteers.

This was my first experience working with a museum. My relationship with the DMA began when I received support from the Museum's Arch and Anne Giles Kimbrough Fund for my travel to Uganda. Soon after that, I talked with Susan about her vision of having visiting artists at the Center, and we went from there. The Museum is an incredible resource of people, ideas, and, of course, art. Interacting with such an active organization essentially fed my creativity. Every step—having conversations with the staff, working with the participants, and designing the installation—opened my mind to new possibilities as an artist. I was challenged in different ways than in my studio. My work became about others, not just about myself. It was not simply about creating one piece for an exhibition, but about engaging with the community along the way. Each group I interacted with influenced what the final work would be, and molded how I thought about the space in the Center and how I imagined the community would interact and engage within it. The Museum opened a new way of working that, for me, is such a natural and exciting process. I walk away from this experience with a desire to do more.

LATE NIGHTS AT THE DALLAS MUSEUM OF ART

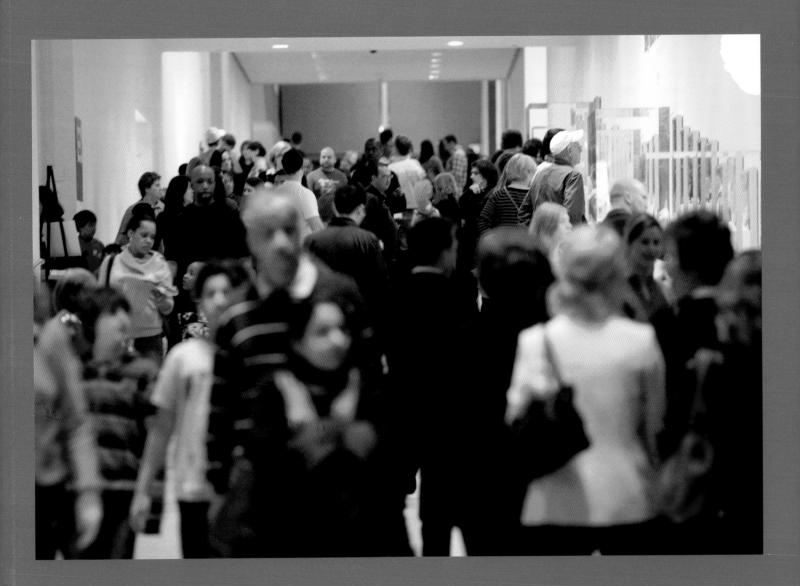

The art doesn't go home. Why should you?

On the third Friday of each month, except December, the Museum is open until midnight with performances, concerts, readings, film screenings, tours, family programs, and other experiences for visitors of all ages. Late Nights at the Dallas Museum of Art are the Museum's signature effort to reach more people on their own terms and their own schedules. When community members talk about the excitement generated by the renewed, accessible DMA, Late Nights usually lead the conversation. The attendance figures are impressive. On a typical Late Night, between 2,000 and 5,000 visitors stop by the Museum, staying for an average of three and a quarter hours. Many Late Night participants from all visitor clusters spend time in the galleries, looking at art and talking about what they see. They say that they are attracted by the program choices and the opportunity to socialize with old friends and new acquaintances.

Late Night themes typically relate to a current exhibition. Most nights, visitors can expect concerts and performances, a film or two, open mic poetry readings, and a lecture. Tours of the featured exhibition are on the schedule, along with a regular Insomniac Tour. For families, there are art-making activities, a yoga class, and bedtime stories with the Museum's mascot, Arturo, all in the Center for Creative Connections. Every January Late Night celebrates the DMA's birthday and the anniversary of Late Nights. A kick-off parade launches an evening of popular programs, some designed for this special occasion. Attendance is among the highest of the year.

Recent Late Night experiences illustrate the creative range of program possibilities. In the summer of 2010, Late Night Block Parties featured outdoor concerts and film screenings, strolling musicians, artist demonstrations, and family activities, all presented in partnership with the Dallas Arts District. Visitors could also tour the DMA, the Nasher Sculpture Center, and the Trammell and Margaret Crow Collection of Asian Art.

During *All the World's a Stage*, Late Nights celebrated the art of performance: flamenco, salsa, and can-can dancing; film screenings; and opera, theater, musical, and dance performances. Family activities included Late Night Creations, where children could build their own stage sets and costumes, and Creativity Challenges. The Dallas Theater Center and Dallas Black Dance Theatre previewed their latest performances in celebration of the new AT&T Performing Arts Center.

When *The Lens of Impressionism: Photography and Painting along the Normandy Coast, 1850–1874* was on view, Late Nights celebrated French culture and the era of impressionism with classical music concerts highlighting French composers, DJs spinning French music in the galleries, French wine tastings, artist demonstrations featuring photographers who still use historical photographic processes, lectures on Monet, French 101 classes, and tours of the exhibition.

The Late Nights program is based on two assumptions.

First, extended hours interest visitors who cannot come to the Museum at other times. Although more visitors tend to arrive early than stay late, the perception that the Museum is open late is a drawing card, especially for those who like to control and design their own museum experiences.

Second, with a menu of more than 20 programs, each audience cluster is targeted on a single evening.

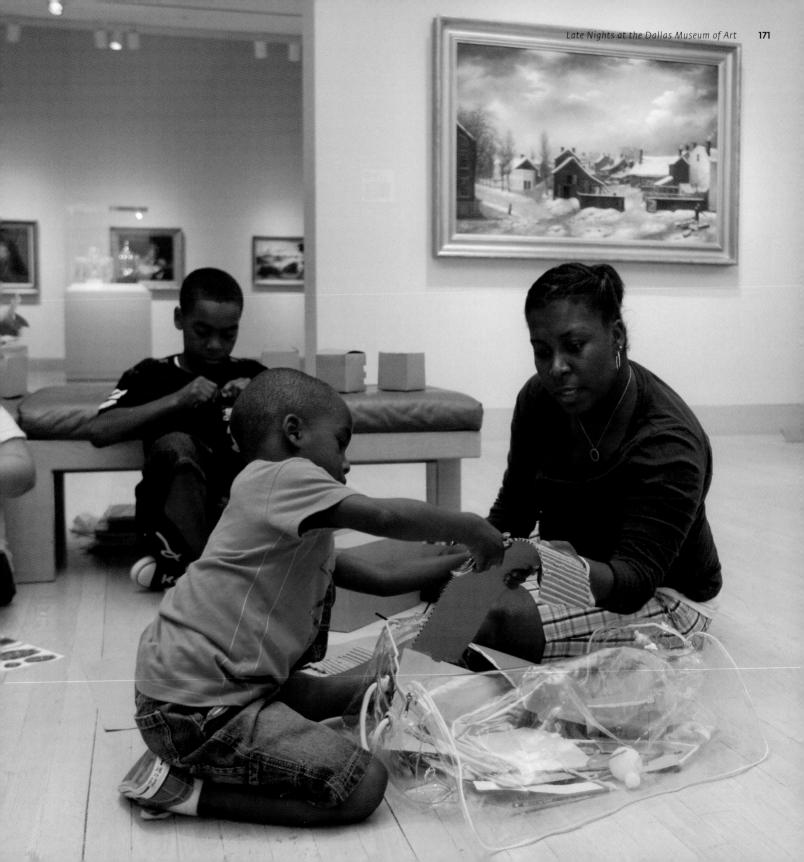

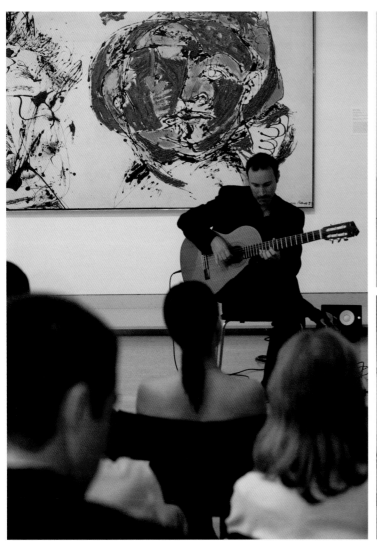

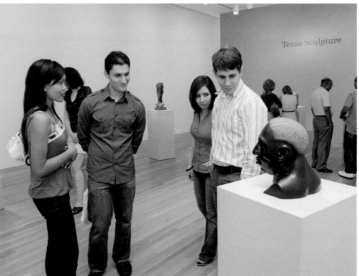

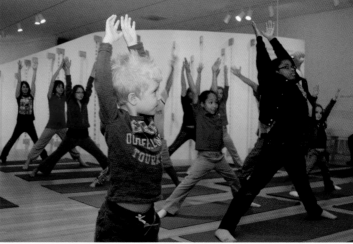

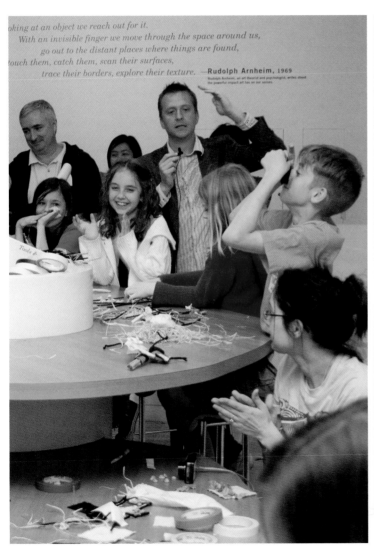

ooking at an object we reach out for it.
With an invisible finger we move through the space around us,
go out to the distant places where things are found,
touch them, catch them, scan their surfaces,
trace their borders, explore their texture. —**Rudolph Arnheim,** 1969

Rudolph Arnheim, an art theorist and psychologist, writes about the powerful impact art has on our senses.

Participants and Enthusiasts like opportunities for social interaction and participatory programming. They look for multiple interpretive methods for connecting with works of art, such as music, dance, dramatic performances, and readings, all options they find at Late Nights. Creativity Challenges, potentially appealing to both these clusters, are artwork-inspired social experiences in which teams compete for creative bragging rights by spreading out on the floor in the galleries to talk about specific works of art and design their own creations within a one-hour time limit. The challenge called "A World of Its Own" calls on visitors to create a shoebox-size imaginary world where a sculpture might live, while "Bring It to Life" asks teams to dress one member as a painting or sculpture. Creativity Challenges connect visitor experiences in the collection galleries with the concept that is basic to the Center for Creative Connections. Enthusiasts are especially comfortable talking about and explaining works of art to a friend, so the social environment of Late Nights should be attractive to them. Independents like to control their own experience, so they are also a good match with the extended hours, menu of

choices, and one-of-a-kind opportunities. Thus, we hope we can attract more Independents in the future.

People in the Observer cluster are least interested in connecting with art through music, dance, performances, and readings, so one goal in Late Night planning is to increase Observers' comfort levels in a variety of other ways, including creating a stress-free experience, presenting clear and simple logistics, providing introductory art tours and programs, and offering expanded programming in the Center for Creative Connections.

Evaluation indicates that most people attend Late Nights as couples or with groups of friends, confirming the value of a museum experience for social interaction and relaxation; in the words of one visitor, the Museum is "a good place to people watch." Activities that were reported frequently include exploring the galleries, attending a performance in the Atrium, and dining in the restaurant. Visitors felt that Late Nights contributed to their appreciation for the arts: When asked to rate DMA

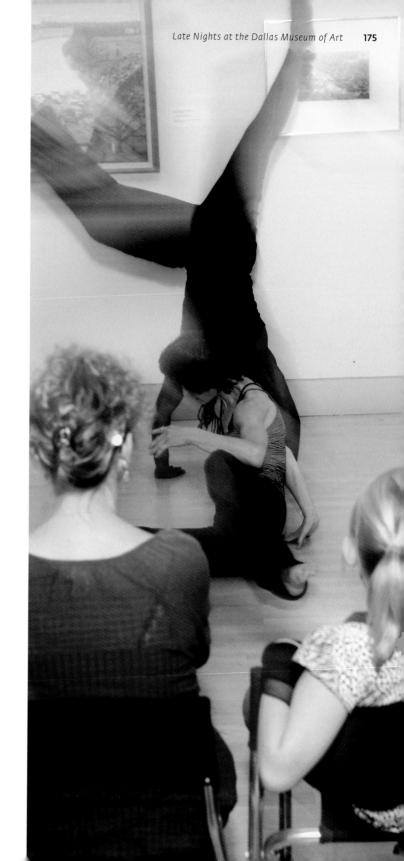

programs on a scale of 1 ("did not help me appreciate the arts") to 7 ("helped me appreciate the arts"), they gave Late Nights a positive rating of 6.1.

As a significant vehicle for expanded visitor access and engagement, as well as high public visibility for the Museum, Late Nights continue to be a programmatic and financial success. Because they target every cluster, Late Nights are one of the most successful Museum initiatives that directly use FEA as a program-planning tool and have helped attract a widely diverse audience.

The Late Nights Web site, http://DallasMuseumofArt.org/ Events/LateNights, provides a current list of exhibitions, programs, lectures, and events for each Late Night.

TEACHER PARTNERSHIPS

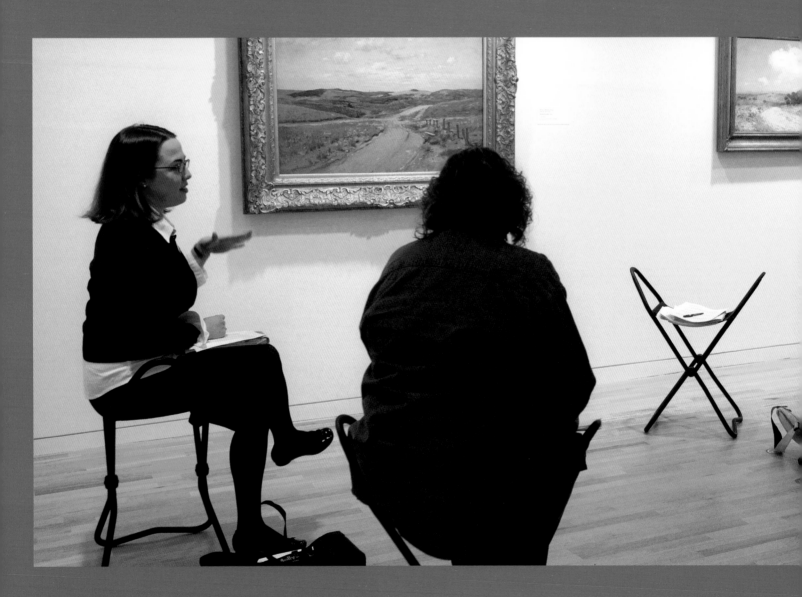

With its long history as a resource and partner for educators and schools in Dallas and the greater North Texas region, the Museum naturally sought to extend the Framework for Engaging with Art research to teachers. Like the change that visitor clusters have inspired at the Museum, new directions in teacher programs are defined by reinvigorated attitudes, interactions, and working culture.

Four hundred fifty Dallas-area educators in grades K–12 participated in the 2007 study of teachers' engagement with art. Forty-three percent of the respondents were practicing artists and 49 percent were visual arts teachers. While three-quarters of teachers were Enthusiasts and Independents, Participants were not present in these findings. This result suggests the importance of context in how visitors choose to engage with art. When teachers come to the Museum, they

have a specific purpose: creating a goal-oriented educational activity for their students.

The report challenged the staff's assumptions about teachers in the Museum and forced them to consider doing things differently. "We became aware that we had always been doing things the same way," says Molly Kysar, Head of Teaching Programs. "We wanted to start fresh and think about what we offer, why, and whether our model was the best way to serve teachers." Her colleague Nicole Stutzman, Director of Teaching Programs and Partnerships, agrees. "Realizing that many of us work directly with teachers," she says, "we saw the opportunity to work together in new ways."

Resources and programs for teachers at the Dallas Museum of Art include online teaching materials based on the collections, Saturday workshops and evening programs, a two-week summer graduate-level seminar, and a weeklong summer program on teaching modern and contemporary art. Learning Partnership programs with schools, universities, and community organizations also involve educators with their students in interactive, in-depth learner-directed experiences that promote interdisciplinary and cross-cultural connections with works of art.

An immediate result of the research on teachers was reinvigorated staff working relationships. A new K–12 team, consisting of Museum education staff from Teaching Programs, Learning Partnerships, and Visitor Studies and Evaluation, met biweekly to develop a better collective understanding of how to serve teachers. In the process, staff interaction was transformed from cooperative to collaborative, from comfortable to experimental. What had been diffuse ideas about potential educator programs, resources, and relationships became a defined and shared vision. As it became clear that more staff should participate in these discussions, the team disbanded and folded its work into regular monthly staff meetings.

The second product of the teacher study—and its most significant programmatic impact so far—has been a large-scale revision of online teaching resources. During 2010 and 2011,

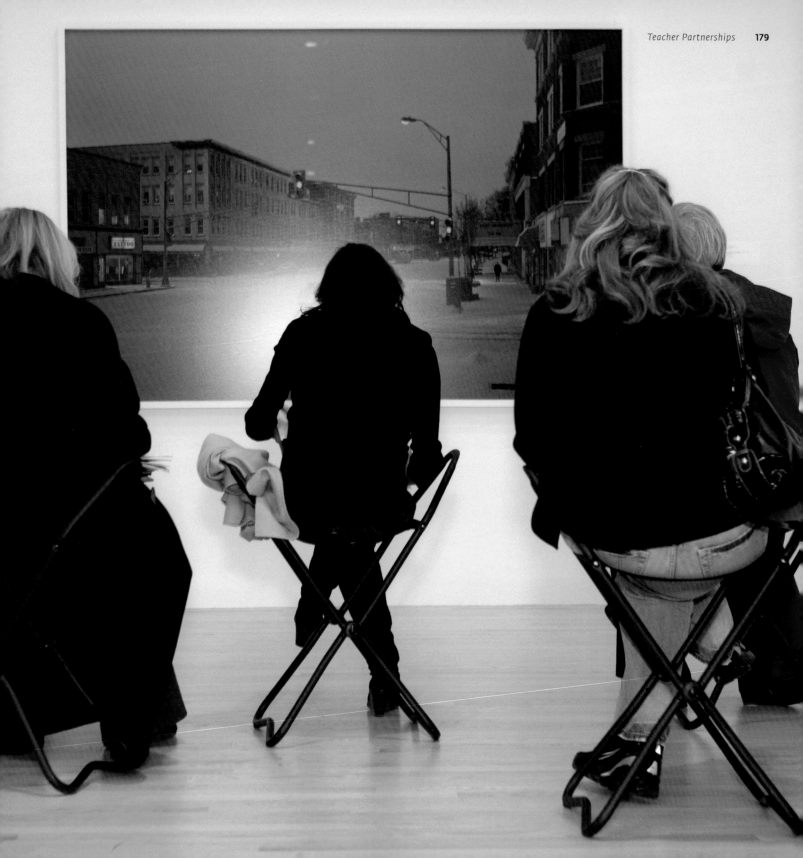

with the support of a Museums for America grant from the federal Institute of Museum and Library Services, the Museum is developing a model for Web-based teaching units for classroom use. The units incorporate recent research on the African and South Asian collections, employ the user-friendly technology of the Arts Network (see pages 200–07), and apply FEA research findings about teachers.

Twenty classroom teachers who reflect qualities of Observers, Independents, or Enthusiasts and represent various disciplines and levels of K–12 teaching are collaborating with education staff to develop the five teaching materials units. Their content and organization will engage multiple teaching styles and art-viewing preferences while mining the Museum's growing collection of digital assets to shape customized classroom experiences. "Most of our resources used to take an art historical approach," Stutzman says. "Now, based on our FEA study, we're aiming for more dynamic materials that reach a mixed audience by providing choices within each unit that reflect the diverse ways teachers learn and teach."

An Independent high school art teacher who is interested in materials and techniques might choose several options for a unit on African art, including X-ray images of an African power figure that reveal hidden materials and a video of a Museum curator discussing the sculptural innovations of the artist Olowe of Ise. When teaching about world cultures and religions in a sixth-grade social studies class, an Observer teacher could present a *stupa* from the Museum's Buddhist galleries with audio clips of a Buddhist monk sharing basic information about the object's symbolism and function. Once the initial units have been designed, tested, evaluated, and launched, they will provide a practical, low-cost model for developing and delivering educational content to a wide audience, and will serve as a blueprint for assessing and redesigning the Museum's other 25 units and creating new ones.

FEA research also guides Museum educators in developing new offerings for teachers that stimulate creativity, merge art and technology, and use peer-to-peer teaching techniques. Responding to the fact that many Independent and Enthusiast teachers identify as practicing artists, Molly Kysar worked

with Susan Diachisin to develop workshops on the materials, design, and meanings of objects—specifically chairs—in the collection. Another workshop, "Exploring Photography," incorporates a session in the galleries with education staff and a follow-up studio session on historical photographic processes, led by an artist and a teacher. Based in the C3 Tech Lab, a teacher workshop series in spring 2009 explored technology (blogging, Adobe Photoshop, and sound design) as a tool in the interpretive process. C3 was also a catalyst for 2008 and 2009 Summer Seminars on teaching through technology. Teachers become active learners in the Center, and they take away strategies, techniques, and actual classroom projects that support their teaching goals.

Just half of the teachers surveyed in 2007 said they attended teacher workshops. Aiming to attract a larger community of teacher-learners, the 2009–10 schedule reaches multiple clusters by offering different program formats, times, and themes as well as opportunities for conversations with other educators and interaction with artists. Building on the success of Late Nights and Thursday Night Live for the general audience, the Museum introduced Thursday Evenings for Teachers, with featured programs led by education staff. For one program, teachers joined textile artist Lesli Robertson for a conversation about her creative process and then worked with her to make a small collage that was incorporated into her *Woven Records* installation. Staff members created the Dallas Museum of Art Educator Blog (DMAeducatorblog.wordpress. com) as an online resource and forum where teachers can get the latest information and exchange ideas with peers.

The staff now knows more about who teachers are, how they teach with works of art, and how the Museum contributes to their teaching. With this understanding, Museum educators can develop resources and experiences that more fully meet teachers' needs. FEA research also helped describe teachers in disciplines other than visual art, who are primarily Observers. This information triggered new approaches to program content and marketing. As education staff re-envision the relationship with educators in light of new understandings, the ultimate prize will be engaging more students in art through Museum experiences.

COMMUNITY VOICE

AUTHENTIC COLLABORATION

Gigi Antoni

President and CEO, Big Thought

The Dallas Museum of Art has all the hallmarks of a true community collaborator: engagement, inclusion, quality, and responsiveness. It has always been a major presence among area cultural institutions, yet there was a time when it seemed closed off from the real community. Now, it has opened its doors in new ways. It's interdisciplinary, interactive, accessible, and a gathering place for conversation about important issues. It's the go-to place for collaboration and innovation in North Texas.

At Big Thought we use community-wide collaboration to fulfill our mission of making imagination a part of everyday learning for children and families in urban settings. The DMA has always come to the table in a leadership role in every collaborative effort that affects the community as a whole. They don't just participate. They lead.

One of Big Thought's early programs was Dallas ArtsPartners, a collaboration with the Dallas Independent School District, the City of Dallas, and more than 50 organizations. The DMA was instrumental in our conversations about evaluation and assessment. How would

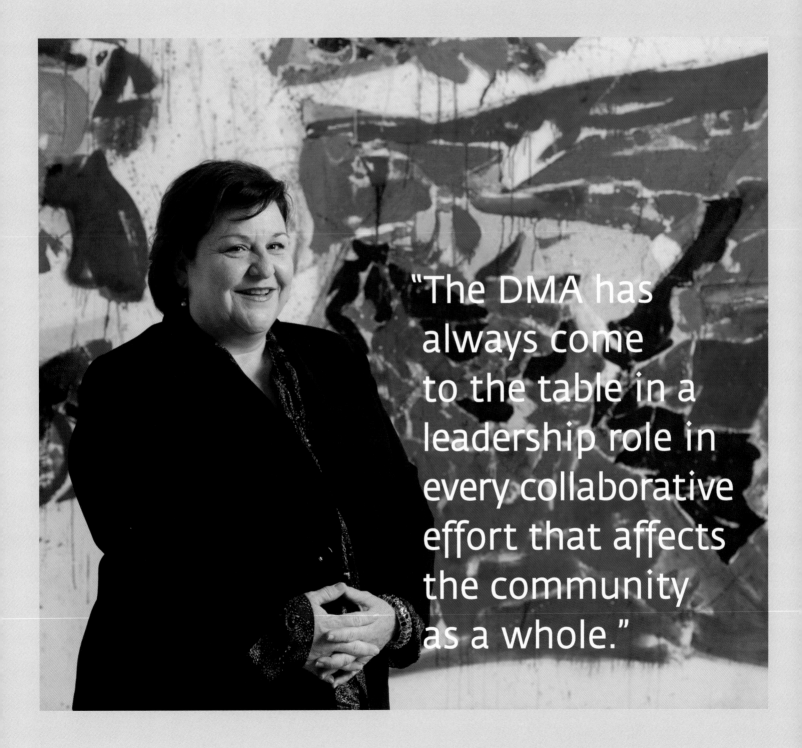

"The DMA has always come to the table in a leadership role in every collaborative effort that affects the community as a whole."

"The Dallas Museum of Art isn't just opening up the Museum. They're opening up the creative process."

we know as a community that we were adding value to learning for children? The Museum helped convene the discussion, hosted it, and gave it leadership in the form of Gail Davitt's participation as committee chair. That's meaningful leadership at an intellectual level.

Then there's on-the-ground leadership. Big Thought's Thriving Minds initiative has created a citywide network of sites for in-school and out-of-school experiences, including cultural hubs where families can create art together, right in their own neighborhoods. The DMA designed a wonderful community project based in a library in South Dallas. People from the neighborhood brought in artifacts that to them represented neighborhood life, and a teaching artist helped them create memory boxes that were displayed in the middle of the library. More than any other organization, the DMA really dug in and put a lot of effort into developing a program that would communicate the idea that you can have a museum in your own neighborhood, anywhere in the city.

The DMA is fully dedicated to the idea of collaborating across institutions and across geographic, socioeconomic, and cultural barriers. The staff understand that we are so much

stronger if we can find ways to leverage our assets as a community. That's why they take the kinds of risks they take. They value the fact that a community perspective—not just a fine arts perspective—is an important element to incorporate in a museum that's at the center of civic life. They build other, less mainstream points of view into the way works of art are interpreted.

On several occasions I've been invited to sit around a table with Museum staff who are planning an exhibition and want to hear from different perspectives what might engage particular parts of the community. The Museum doesn't do this in a shallow way. It's a major part of the staff's thinking about how they put an exhibition together. I think that's pretty remarkable. Sometimes, even a few months later, I'll think of a connection we could make to an exhibition through a Big Thought program, just because I was in the room and part of the conversation. Partnership works when there's an authentic, value-added benefit to working together rather than working separately. But it's hard to see those potential benefits if you're not collaborating on planning across institutions and across stakeholder groups. The Dallas Museum of Art isn't just opening up the Museum. They're opening up the creative process.

The DMA has an absolute commitment to its community. They're ready to take on leadership roles, and they're willing to respond to community needs by developing and customizing programs and partnerships that fill gaps or meet a need. Many organizations talk a lot about outreach and collaboration. The DMA walks the talk.

A VISITOR-FOCUSED IDENTITY

Strategies for engaging visitors and attracting members are closely linked to having a clear, vibrant identity that the public relates to, remembers, and respects. As the Dallas Museum of Art planned for its Centennial celebration in 2003, it lacked the recognizable identity needed to launch its second century. There was no positioning statement that expressed how the Museum sought to be viewed by the community and no brand promise that focused on what the Museum offered. The communication strategy was not well formed, and marketing messages were inconsistent and unclear to members, visitors, and new audiences it was trying to attract. And most important, the cross-departmental communication and collaboration that could power a strong and dynamic identity were limited. To Judy Conner, Chief Marketing and Communications Officer, those were critical missing pieces. Without them, "all our efforts were shots in the dark."

The Museum launched an intensive branding initiative that would communicate a unified voice, a welcoming environment, and a visitor-focused mission. Meanwhile, discussions with community groups, conducted in the context of FEA research, revealed some eye-opening facts:

- The Museum was not in the "consideration set" for leisure-time outings.

- The cultural arts were under-penetrated in Dallas compared with other top metro markets.

- The pervasive attitude among residents was that there is nothing to do in Dallas but dining, shopping, and going to the movies.

- There was little to no awareness of the breadth, depth, and quality of the DMA's collection and programs.

The future vitality of the Museum demanded an increased community awareness of its offerings, capabilities, and long-term potential.

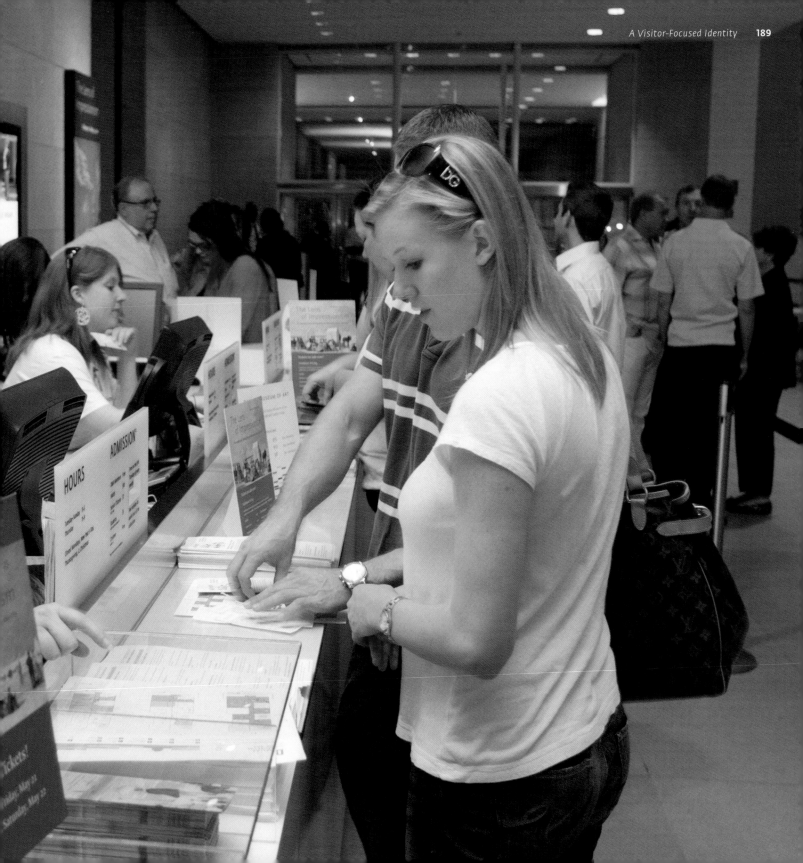

The DMA developed a new graphic identity with Pentagram, a multidisciplinary international design firm, and pursued a commitment to living and championing both the brand identity and the FEA research findings. "It's all about the visitor," Conner says. "The common thread is engaging visitors more fully and intimately with our collections." Every form of communication reinforces that point. FEA "gives us all a shared vocabulary," she continues. "It helps us have conversations around exhibition and program planning. It's about more than programming and education. It's about the whole visitor experience." Working with *latitude*, a division of the Richards Group, a national advertising agency, senior management and trustees crafted ideas and language that would lead to this brand promise:

Brand Mission

Ignite the power of art through engaging experiences.

Brand Positioning

To people who want to be transported out of the everyday, the Dallas Museum of Art is the entertainment option that captivates the imagination and sparks discovery through engaging new experiences with art, every visit.

Brand Personality

Vibrant – Visionary – Captivating – Friendly – Intelligent – Trusted

As part of the Centennial year, the Museum launched its reinvigorated identity. Coming together across departments, the staff focused on creating positive visitor experiences, mindful of both the Framework for Engaging with Art and the brand identity. The whole environment took on a more welcoming look and feel, and staff were trained to make visitors comfortable. The Brand Champions Committee met monthly from 2003 to 2009, making changes in operations based in part on FEA findings. The committee was succeeded by the New Visions Team, which includes even more staff representation and meets every week. The goal of this group is to attract new audiences in all four clusters and promote visitor-centered, research-based strategies. In the current economic climate, this commitment requires flexible decision making and ongoing attention to the allocation of marketing and membership dollars.

The psychographic and demographic characteristics of the Museum's audience are the most useful aspects of FEA research for marketing purposes, especially with diminished resources. Having empirical data helps

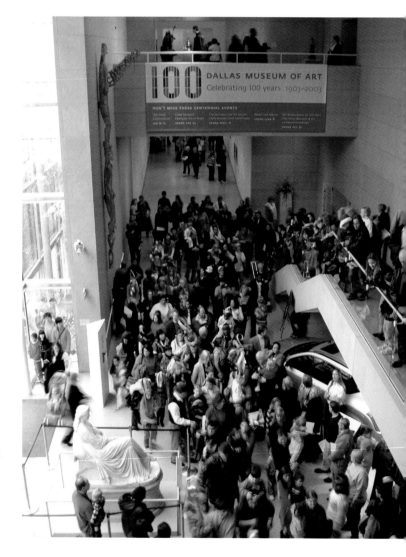

marketing staff decide how to invest dollars most efficiently, affecting media messages, media-buying choices, and promotional and media partnerships. For *All the World's a Stage*, an exhibition that appealed to visitors who are relatively knowledgeable about art, the Museum targeted culturally active audiences. Given the nature of the material and the audience makeup, radio was considered the best option. For the broadly popular traveling exhibition *The Lens of Impressionism*, television made more sense because of its wider reach and its capacity to attract an audience interested in entertainment options. Although exhibitions are a big attendance driver, the DMA also puts significant marketing resources and energy toward promoting DMA collections and programs. From 2003 to 2010, it used the tagline "Hundreds of experiences. Have one of your own" to convey that there were new experiences to be had every visit because of the broad array of programs and the Museum's encyclopedic collections. The Museum regularly works with media and promotional partners to spread the word on programs and reach additional audiences. For Thursday Night Live, for

example, radio stations announce the Jazz in the Atrium series and promote the station's appearance onsite to provide exposure for the DMA.

Exhibitions and programs are also promoted through social media such as Facebook, Twitter, Flickr, and YouTube. The Museum's social media presence has grown dramatically since 2009, supporting the commitment to engage visitors with the Museum and with each other. "Using social media is not just a marketing strategy," says Judy Conner. "It's a way to build community by nurturing people who have an interest in the Museum, want to know more, and hope to connect with others who share their interest." Launched in spring 2009, the Museum's Facebook page (http://www.facebook.com/DallasMuseumofArt) attracted over 15,000 followers in less than 18 months, and the number grows daily.

The DMA's Facebook Wall is a lively place that stimulates dialogue about all facets of the Museum. Regular status updates, written by staff and targeted to visitor interests, give current information on exhibitions, public programs,

family activities, free admission opportunities, dining and shopping, and more. A photo series called DMA Days and Nights takes Facebook followers behind the scenes for a unique close-up look at staff at work. People respond on the Museum's Wall with feedback about their visit, a favorite lecture, or a Late Night happening. True to the intent of social media, these comments prompt more comments, questions, and opposing viewpoints, and the DMA responds to each one. Some Facebook users share their own content, including personal blog posts, reviews, videos, and photos.

Developing and testing creative social media strategies is a work in progress. The DMA, Judy Conner says, "has made remarkable progress in a short time with few resources. But we're still learning and experimenting as we work to make it a successful tool to promote the Museum and expand our audience."

In the area of membership, FEA research data help the staff craft specific messages and refine membership benefits based on known characteristics of each cluster. "Our goal is to have members visit the Museum consistently, have positive, deeper experiences appropriate to their interests, and feel value for their memberships," says Linda Lipscomb, Director of Individual and Annual Giving. Enthusiasts represent only 12 percent of first-time visitors, while 50 percent are members, demonstrating their strong commitment to the DMA. Approximately 70 percent of each of the three remaining clusters are repeat visitors, while just 30 percent are already members, leading us to recognize the potential for increasing levels of membership. Despite the similarities among the latter three groups, they take different approaches to engaging with the Museum, so we have refined our strategies:

OBSERVERS have the most potential for onsite recruitment through strategies that help them learn about the Museum, experience what it has to offer, understand options for involvement, and become aware of the value of membership.

PARTICIPANTS can be approached through direct, personal connections and encouraged to see their

active role in the Museum's many interdisciplinary programs. They are particularly interested in social interactions.

INDEPENDENTS can be enticed to become members through special programs for specific membership levels that provide more directed learning.

ENTHUSIASTS already actively attend and support the DMA and could be encouraged to join at increased levels.

Based on the hypothesis that all four clusters populate each membership level, we include a menu of programs for every large event: Member Nights, for instance, offer docent tours intended for Observers, treasure hunts for Participants, and special evenings with lectures for Independents and Enthusiasts. If an event could appeal to a specific cluster, invitations go to a range of membership levels to assure good attendance.

FEA also shows that each visitor cluster includes first-time visitors (who make up one-quarter of our audience),

overturning our assumption that we have already reached all the art lovers in the community. Efforts to connect with a younger and more diverse audience are bolstered by the FEA research finding that 37 percent of visitors who are attending the Museum for the first time are under age 35.

Awareness of the DMA increased significantly over 10 years, according to a 2007 image and awareness survey that followed up on an earlier, 1997 study. The DMA was top-of-mind among arts and culture institutions in the region, as the number of survey respondents who mentioned it most often without prompting increased from 25 percent to 37 percent. With a strong, vibrant, and visitor-focused brand, a Museum-wide spirit of collaboration, and an embrace of FEA, the DMA is targeting visitors and members in increasingly refined ways. The result is not just greater awareness, but higher attendance numbers, more satisfied members, a diversified audience, and for all who come, a deeper engagement with art.

COMMUNITY VOICE

DOWNTOWN ANCHOR

Anne Brown
National Audubon Society

Brent Brown, AIA
buildingcommunity WORKSHOP

Anne Brown: I grew up in Chicago, where my grandmother took me to museums all the time. The cultural institutions there are inclusive. Everyone seems to go to the Art Institute, or the Field Museum, or the Chicago History Museum. You don't think twice about it. When I moved to Dallas, I didn't have that same feeling. I was surprised that visiting the art museum wasn't a regular pastime like it is in other cities. I even got the impression that people were almost afraid to come to the Dallas Museum of Art. But seven years later, the culture of the Museum is different. There's been a real change in perception. Now, the DMA is about more than art. It's about people *and* the art.

Brent Brown: It's a much more welcoming place, inside and out. Museums are often seen as vaults, as containers for art. They have collections, and it's their responsibility to protect them. The DMA has opened up the notion of what a museum should be. It's not just a passive holder of collections, but an active way of engaging people with those collections. It's also a place to have fun, to be playful. Now that we have a young son, we're finding out

"The DMA has shown that an art museum is not just a 'don't-touch' environment... Instead, it can be interactive, lively, and appealing—for people of all ages."

what that means. At a recent Late Night he had a great time dancing in the Atrium with other kids to music by a jazz group. The DMA has shown that an art museum is not just a "don't-touch" environment. That can be overbearing for children. Instead, it can be interactive, lively, and appealing—for people of all ages.

Anne: We moved to downtown Dallas because we wanted our son to grow up in an urban environment surrounded by cultural institutions. If you live downtown, you can walk a few blocks, go to the Museum, get involved in some of the programs or activities that are happening there, or see an exhibition. It's an anchor that helps create a more livable downtown. It's challenging at times living where we do, because there isn't much green space where you can go for some quiet relaxation. The DMA Sculpture Garden has wonderful spaces and great works of art, right in the center of an urban setting. It's another, slightly different way the Museum engages people with works of art—outdoors, in quiet surroundings. It's a perfect place for introducing children to sculpture.

Brent: It's also important to understand how much the Museum supports local artists and the relationships it has in the local art community. By employing hundreds of local artists every year they're strengthening that community. I've talked to people from other cities, even New York, who find this amazing. It's impressive how the DMA has developed a pattern and a rhythm of being open and inviting. We talk a lot about needing incentives to spur development downtown, and the Museum has filled those needs.

ARTS NETWORK

Informed by research-based discoveries about the ways visitors engage with art, the Dallas Museum of Art is developing 21st-century technology solutions that invite people to create their own personal experiences. Through the in-house and Web-based Arts Network channels, a broad audience can connect with the Museum's extensive digital resources—before, during, and after looking at art in the galleries. This initiative is transforming how visitors gain access to content in the Museum and online, and how staff create new programs, from concept to completion.

The Arts Network has three access points, or channels. The Museum's main Web site and preferred point of entry (DallasMuseumofArt.org) was redesigned in 2009 using information gathered from earlier FEA studies of online visitors. Continuing research will help staff further develop and refine its usefulness.

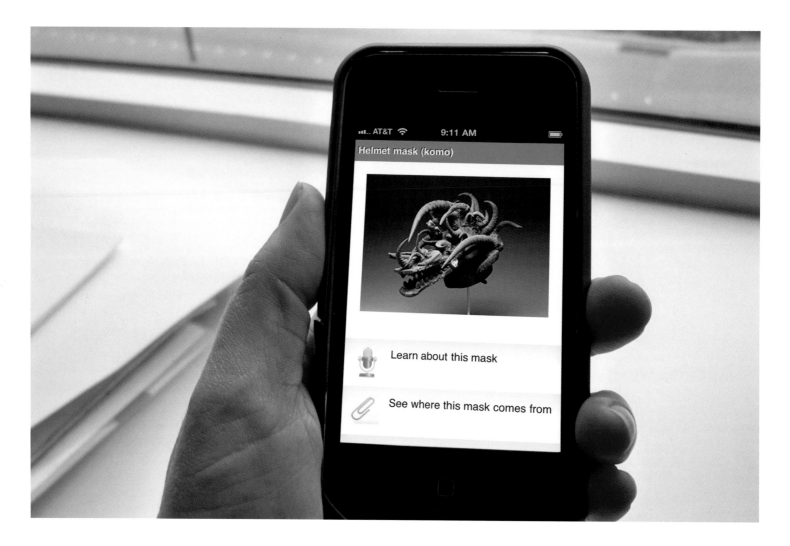

The second access point, DallasMuseumofArt.tv, offers direct access to all multimedia content, exhibition-related materials, podcasts, and artist films. A success story since its launch in 2008, it is expanding in 2010 to include even more Museum assets. The staff plans to test new ways of categorizing, searching, and disseminating the materials.

The Museum's mobile site, DallasMuseumofArt.mobi, is a media-rich project offering access in the galleries to specially formatted introductions, interviews, films, text, and other materials about the collection, targeting Web-enabled wireless devices such as the iPhone, BlackBerry, and iPod Touch. The mobile site was launched and evaluated with *Summer Spotlight*

in 2009 and relaunched in 2010 with expanded smARTphone content related to the *Lens of Impressionism* exhibition and the Wendy and Emery Reves Collection.

The Arts Network is grounded in FEA research. A two-part study of online users—a baseline study in 2008 and a follow-up study in 2009 (see pages 102–05)—confirmed that many use the Web site as a practical planning tool. They check for details about the current exhibition and related programs, or they look for information about hours, directions, parking, and ticketing. The 2009 study (conducted after the launch of the new Web site) shows

expanding online interest in exploring the Museum's collections, exhibitions, and programs. With more online content based on choices related to the FEA audience clusters, Web site use is likely to increase as people recognize and enjoy its diversity.

The Arts Network is not a static interpretive program. Instead, it offers visitors access to the Museum's growing collection of digital assets—images, library holdings, audio and video program recordings, digitized documents from the archives, interviews with related transcripts—to create their own experiences according to their needs or interests at any given moment. We understand that visitors will always want information for planning their visits. The idea behind the Arts Network is to give people the option to dig deeper by offering varied content using the method they are most comfortable with—at any time, anywhere. We hope:

OBSERVERS can read or listen to brief introductory comments about works of art online or watch a short video about Jazz in the Atrium before attending an event.

PRAGMATISTS can find information about hours, tour schedules, ticket pricing, and parking. Collection-related videos are just a click away at DallasMuseumofArt.mobi or DallasMuseumofArt.tv. Pragmatists can also get involved in social networking on Facebook, Twitter, MySpace, and Flickr. Inside the Museum, dynamic digital signage provides almost real-time information on current and upcoming events and activities using the same Arts Network principles.

INDEPENDENTS can search the Mildred R. and Frederick M. Mayer Library's online catalogue, customize a visit using a menu of choices on a smARTphone, or watch behind-the-scenes videos of students creating a soundscape for an exhibition or Museum preparators discussing the construction of an exhibition.

ENTHUSIASTS surfing the Web site might enjoy interviews with Dallas-area collectors speaking about works of art or recorded conversations with dancers and actors discussing the creative spirit of performing. Enthusiasts can also browse virtual catalogues from current and past exhibitions.

The Arts Network reflects the purposeful visitor focus and collaborative work style that have been emerging at the Museum since the development of FEA. It is:

- Mission-driven, supporting the Museum's goal of engaging new audiences with collections and programs
- Art-focused, providing diverse content derived from the collections, presented in different ways, and designed to engage both online users and Museum visitors
- Audience-focused, with multiple access points—a Web site, a mobile site, and a media site—that intentionally appeal across all four visitor clusters
- Research-driven, based on user comments and FEA findings
- Collaborative, replacing departmental units with cross-departmental teams
- Experimental, allowing staff to fail, learn, redesign, and try again using existing staff and reusable resources and tools

Instead of building a complex system with authority isolated in one department, the Arts Network team approach promotes a high degree of ownership across the Museum. "The emphasis is on the quality of programs, quick time to market, and the development of new, experimental ideas, not on end-user devices," says Information Technology Director Homer Gutierrez. The software is mostly implemented "out of the box"—reducing the learning curve for nontechnical staff.

Records of the Museum's collections and programs are being centralized and stored in two management systems. One system is dedicated to all aspects of the object collection and includes records such as provenance, exhibition histories, conservation information, and label text, and the other system holds documentary and related collections, including photographs, checklists, and audio and video material featuring artists, curators, and collectors. With a Leadership Grant from the federal Institute of Museum and Library Services, the staff completed an inventory and documentation of programming recorded over 25 years. From 1,748 existing audio and video recordings, 600 met predetermined specifications and were digitized. In addition, more than 300 new program recordings from 2006 to 2009 have been transferred to the digital archives and catalogued, and the process is ongoing. Most of these resources will be available on the DMA Web site and through other

appropriate distribution channels. Examples of the digitized programs include a video of the 1985 installation of Sol LeWitt's *Wall Drawing #398* in the Barrel Vault, the lecture "The True History of Chocolate" given by the anthropologist Michael Coe in 2006, an interview with Roy Lichtenstein by Robert Rosenblum of 1995, and conversations with local collectors Marguerite Hoffman, Howard Rachofsky, and Deedie Rose from 2007.

The Web sites are designed and maintained in-house, giving the staff complete control over content, usability, and schedule. Because the process is automated, content experts in every division can create, store, manage, catalogue, and distribute resources easily. When education staff want to

add or revise content for teachers, for example, they do it themselves using internal tools and procedures. In-house staff training teaches the fundamentals, and accessible training materials serve as reference guides. "We're empowering users to be contributors," says Jessica Heimberg, Project Manager and Senior Web Developer.

By investing in the Arts Network, the DMA can provide innumerable ways for visitors to engage with art and creativity both now and in the future. Digital assets are a part of everyday experience, including interactions with art, and experimentation will continue at the Museum as technologies evolve.

COMMUNITY VOICE

CREATIVE PARTNERSHIPS

Dennis M. Kratz

Dean, School of Arts and Humanities, University of Texas at Dallas

Our collaboration with the Dallas Museum of Art began when the Museum's leadership and I realized that we shared the same philosophy of creativity, education, and the arts and humanities. The University of Texas at Dallas is a relentlessly interdisciplinary institution that approaches education through convergent spheres of interest instead of through traditional academic departments. It's a learner-centered rather than a teacher-centered university. In our educational environment, creative thinking is an equal partner with critical, analytical thinking. We want to inspire what I call disciplined creativity, or creativity with a capital C: focused, honed, enhanced creativity that increases a person's capacity for innovative thinking, experimentation, and risk taking. We're more flexible than many higher education institutions because we can act on ideas without having to negotiate with people who are encased in silos.

That's the model the Dallas Museum of Art is pursuing: a visitor-centered museum instead of an exhibition-centered museum, a culture that supports experimentation, and a collaborative

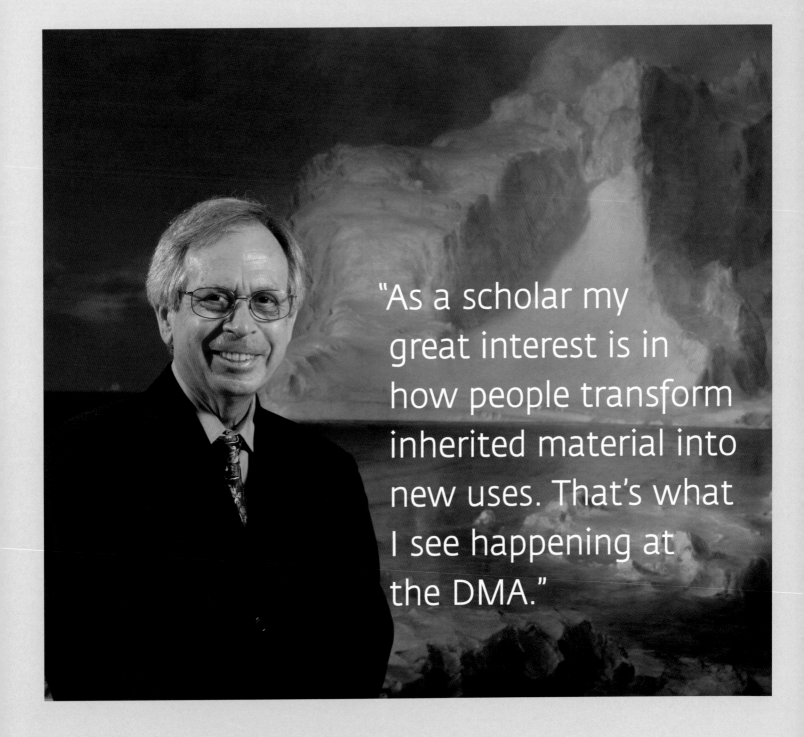

"As a scholar my great interest is in how people transform inherited material into new uses. That's what I see happening at the DMA."

environment where multiple voices contribute to decisions. The UTD and the DMA teams share the belief that the visual arts are one specific manifestation of the human urge to create. Rather than separate creativity into different fields, each with its own vocabulary and its own expertise, we're trying to find the commonalities among different forms of expression.

We collaborate in so many ways with the DMA, but here are a few examples. Every spring semester we offer an Honors Seminar in the Museum. The Museum didn't just invite us to come and teach a course. From the start, we considered how the marriage of the academic perspective and the art museum perspective could lead to something brand-new. The seminar is always devoted to some aspect of the Museum's collection and vision—Maya art and mythology, modernism, the senses in art and literature, creativity. We also cooperate with the DMA on a summer graduate seminar for teachers, working with 10 to 20 educators to explore how they can integrate the collection and programs into their teaching.

For Museum exhibitions, students and faculty have used dance, drama, and music performances to respond to works of art. Our graduate students and faculty in the Arts and Technology program created sound installations that were congruent with what was going on in the works of art in two exhibitions, *Summer Spotlight* in 2009 and *Coastlines: Images of Land and Sea* in 2010.

In 2010 the new Center for Values in Medicine, Science, and Technology that we have founded at UTD organized the free public lecture series "Creativity in the Age of Technology." A lecture at the Museum by photographer Gregory Crewdson, cosponsored by the DMA,

drew an audience of more than 500—so large that some had to be turned away at the door. There were audience members from the community, students, UTD faculty—a real mingling of all kinds of people who came because they were intrigued by the intersection of technology and originality.

American education is at a real turning point, as technology transforms the way we receive information and make it available. Instead of teaching traditional subjects that we believe students should know, we're starting to ask what skills, expertise, and modes of thinking a person needs in the 21st-century environment. The DMA is doing the same thing: reimagining what the museum is about. It's much more than a place where you look at art and go home. It's a place to explore creativity—your own and the artist's. Creative people have connections with people in other domains. If they stay in one domain, they can be successful, but they'll never have that breakthrough moment. If they move outside their comfort zones and encounter other modes of thinking, other perspectives, even other disciplines, they'll gain insights that otherwise would remain hidden from them.

As a scholar my great interest is in how people transform inherited material into new uses. That's what I see happening at the DMA. The staff inherited a museum that was what people expect a museum to be. Now they're saying, Let's enhance and transform what has been inherited, keeping what's good, and make it a more powerful element in the community.

CONCLUSION

FUTURE FORWARD

Veletta Forsythe Lill—avid visitor, community leader, and Executive Director of the Dallas Arts District—recently described the Dallas Museum of Art as

a "people's museum": extroverted, welcoming, and dedicated to connecting people with art.

Those are just the qualities we hoped would emerge when we launched intensive visitor research in 2003. A dynamic renewal is occurring at the DMA, with fresh ideas, revitalized spaces, and purposeful partnerships. The renewal is complex and all-encompassing, grounded in modified relationships inside and outside the Museum that strengthen and deepen our interactions with visitors, and our visitors' interactions with art.

Consider, for example, the collaborative spirit and practices behind *Encountering Space*, the exhibition in the Center for Creative Connections that opened in September 2010. Cross-divisional staff teams worked for 18 months, coming together regularly to create the exhibition, share progress, and move ahead. Curators and educators chose works of art from the collections in conversation with their colleagues on the concept and content teams. With Museum staff, faculty and alumni from the Meadows School of the Arts at Southern Methodist University began developing their creative response to the exhibition, to be installed in the main gathering area of the Center for Creative Connections as a way of introducing fresh perspectives from artists and community organizations. Artists continue to be a crucial part of the staff's thinking about *Encountering Space*.

The DMA's evolving strategy is consistent with a larger movement. Diane E. Ragsdale of the Andrew W. Mellon Foundation, a thoughtful commentator on the challenges facing 21st-century arts institutions, observes that "it's time for the arts to stop waiting for people to find us, to appreciate us, and instead move toward them; seek to understand them; break into their hearts and minds—in that order." Over the past decade, that is precisely what we aimed to accomplish at the DMA as we integrated the Framework for Engaging with Art into our thinking and practice.

Using the FEA research, we have blurred traditional boundaries to create inviting, accessible bridges between visitors and art, visitors and the Museum, and visitors and

and interpretation; and test programs—all to provide an ongoing and informed assessment of our work. We would also like to identify the characteristics of people who do not visit the DMA and figure out how to develop programs and marketing methods to attract them.

The Museum's new strategic plan—endorsed by trustees, staff, and volunteers—articulates the goals of energetically focusing on art, particularly the collection, as well as identifying and securing the resources to assure the Museum's future stability. The strategic planning process began in the same spirit of active listening that inspired our first steps a decade ago to learn more about the Museum's visitors. At 17 community forums, nearly 250 people talked to Museum staff and trustees about what the Museum does well, what needs improvement, and what vision they have for the DMA of 2020. They were resoundingly positive about the renewal and change that they see within the Museum and in its community presence. And they want the renewal to continue: expanded use of the collections, enhanced online capabilities, greater diversity in audiences, more active community engagement, and easier and more welcoming access. With the collection as the drawing card, they expect the Museum to capitalize on its potential as a gathering place for experiencing, enjoying, and learning from art.

The constructive atmosphere at these forums was in marked contrast to the indifferent, even alienated public attitudes toward the Museum of the late 1990s. We attribute much of our progress to what we have learned from research about visitor engagement with art.

The Framework for Engaging with Art gave us a solid institutional strategy and set in motion wholesale change, some of it highly visible and some of it more subtle. The Dallas Museum of Art is vibrant, engaged, and welcoming today—a "people's museum" that remains a fearless, confident work in progress.

FOR FURTHER READING ON THE FRAMEWORK FOR ENGAGING WITH ART

Ignite the Power of Art: Advancing Visitor Engagement in Museums draws on research studies conducted between 2003 and 2009 by the Dallas Museum of Art and Randi Korn & Associates, Inc. (RK&A). Five research reports are available on the DMA Web site at: http://DallasMuseumofArt.org/FEA. (Note that currently the DMA refers to the research as the Framework for Engaging with Art, but the report titles reflect the former name of the DMA's research framework, Levels of Engagement with Art.)

Audience Research: Levels of Engagement with Art, A Two-Year Study, 2003–2005 (October 2005)
Introduces the 10 statements that shaped the Dallas Museum of Art's exploration of its relationship with visitors and describes the four audience clusters that emerged from visitors' ratings of these statements and results from the larger questionnaire. A total of 1,120 onsite Museum visitors were interviewed for this two-part study, providing baseline information about DMA visitors. Based on the ratings of the 10 statements, RK&A instructed statistical analysis software to group visitors into four clusters, which formed the basis for future work on Levels of Engagement with Art/Framework for Engaging with Art. This report, which combines data from the 2003 and 2005 studies, helps the DMA understand the characteristics of its audiences and their preferences for experiencing works of art at the DMA and other museums.

Audience Research: Levels of Engagement with Art, 2008 Study (August 2008)
Presents the results of the third research report, administered to 416 onsite Museum visitors during May and June 2008. The findings further deepened the DMA's understanding of its audience in the context of the Framework for Engaging with Art. To determine if the cluster characteristics were authentic descriptions of visitor engagement, the DMA intentionally administered the study at the time of a J. M. W. Turner exhibition, knowing that the audience would likely be older and less diverse. For this phase, some questions were deleted from the original questionnaire because they

proved to be less relevant to Levels of Engagement with Art/Framework for Engaging with Art theory, and 38 open-ended interviews were conducted to better understand visitors in relation to LoEA/FEA.

Audience Research: Levels of Engagement with Art and Teachers (October 2007)
Provides information about the attitudes and perceptions of 450 Dallas-area K–12 teachers who have a professional relationship with the Dallas Museum of Art and who completed a mail-back survey. The study explores teachers in the context of the four clusters identified among the Museum's general visitor population, with the goal of understanding teachers as important partners and supporting them more effectively.

Web User Research: Levels of Engagement with Art and Arts Network (June 2008)
Includes data from 872 visitors to the Dallas Museum of Art Web site who completed an online questionnaire about their museum visits, art-viewing preferences, demographic characteristics, and experiences using the site. This baseline study was a first step in collecting and analyzing data about DMA Web users and their browsing habits in the context of LoEA/FEA. The information from this study led to a redesign of the DMA Web site.

Web User Research: 2009 Survey of Arts Network Users (January 2010)
Reveals changes in the characteristics and experiences of 536 visitors to the Dallas Museum of Art Web site since the first online study in 2008. The study was completed after the new Web site was launched in summer 2008. It continues to explore viewer preferences based on the Framework for Engaging with Art, including museum visits, art-viewing preferences, demographic characteristics, and experiences using the DMA Web site. Results show that there are more male online users, that Web site visitors are younger, and that visits to art museum Web sites in general and the DMA's site in particular are increasing.

IGNITE THE POWER OF ART
ADVANCING VISITOR ENGAGEMENT IN MUSEUMS

Dallas Museum of Art
Bonnie Pitman, The Eugene McDermott Director
Gail Davitt, Chair of Learning Initiatives and The Dallas Museum of Art League
 Director of Education
Tamara Wootton-Bonner, Chair of Collections and Exhibitions
Eric Zeidler, Publications Coordinator
Giselle Castro-Brightenberg, Imaging Department Manager
Cover designed by Mandy Engleman
All photography is by Carol Brown, Daniel Driensky, Brad Flowers, Ted Forbes,
Adam Gingrich, Ralph Lieberman, Chad Redmon, Liza Skaggs, and Kevin Todora
© Dallas Museum of Art

Co-authored by Ellen Hirzy
Edited by Lucy Flint
Designed by Greg Dittmar/www.dittmardesign.com
Proofread by Laura Iwasaki
Printed and bound by Grover Printing

Distributed by Yale University Press, New Haven and London
 www.yalebooks.com

Library of Congress Cataloguing-in-Publication Data
Pitman, Bonnie.
 Ignite the power of art: advancing visitor engagement in museums /
 Bonnie Pitman, Ellen Hirzy.
 p. cm.
 ISBN 978-0-300-16754-2 (pbk.)
 1. Dallas Museum of Art—Administration—Evaluation. 2. Art museum visitors—
Texas—Dallas—Services for—Evaluation. 3. Art museum visitors—Texas—Dallas—
Attitudes. 4. Art museums—Texas—Dallas—Psychological aspects. 5. Art
museums—Texas—Dallas—Social aspects. 6. Art museums and community—Texas—
Dallas. I. Hirzy, Ellen Cochran. II. Title.

N558.P58 2010
708.164'2812—dc22 2010027462